HAUNTED
SOUTH GEORGIA

HAUNTED
SOUTH GEORGIA

JIM MILES

Haunted
America

Published by Haunted America
A Division of The History Press
Charleston, SC
www.historypress.net

First published 2017

Manufactured in the United States

ISBN 9781625859464

Library of Congress Control Number: 2017940962

To all the bad teachers I endured,
thank you for giving me time to think and imagine.

CONTENTS

CONTENTS

INTRODUCTION

.Ihave been gathering materials about paranormal Georgia since my teenage years, and that was some time ago. Over the past ten years, I have labored on a daunting project: to collect a ghost story from each of Georgia's existing 159 counties, plus 2 counties that went bankrupt during the Great Depression. My wife, Earline, and I crisscrossed this huge state to record firsthand ghostly encounters, search hundreds of old vertical files at libraries and scour two hundred years of Georgia newspapers and magazines, as well as every book relating to Georgia.

For these books—*Haunted North Georgia, Haunted Central Georgia* and *Haunted South Georgia*—I have found stories dating from the present back to prehistoric times, always looking for unique stories with unusual details and largely avoiding the more common ghost tales. Some of the longest stories are from the least-known and populated Georgia counties, while several of the shortest originated in the crowded counties around the big cities. These books are about all of Georgia, from rural to metropolitan. Think of this as state folklore, from the remotest past of Georgia to the present.

These books will appeal to those intrigued by the supernatural and to anyone who embraces the entire Georgia experience and desires to learn a piece of folklore from each of our many small counties. Readers will learn that ghost tales are universal, varying little between regions, centuries and cultures.

My long manuscript has been divided into three books, organized geographically. Georgia is generally divided into three regions. North

Georgia is the mountains; Central Georgia is the piedmont and fall line, which connects the cities of Columbus, Macon and Augusta; and South Georgia is the coastal plain, including Savannah and the coast. These regions are geographic in nature, but here we pull North Georgia down to include Metro Atlanta, and Central Georgia is extended farther south simply because the coastal plain is so large. Each book contains a roughly equal numbers of counties.

As you read, consider Georgia as one large community and not as isolated parts. During your next break, head for a region that you aren't familiar with and get better acquainted with our people.

APPLING COUNTY

IT WAS A DARK AND STORMY NIGHT

Appling County is the site of Georgia's best and most documented ghost story, known popularly as "The Surrency Horror." I told that story in detail in *Weird Georgia* (Cumberland House, 2000). For our official county story, we turn to a native son, E. Randall Floyd, himself a famous name in paranormal writing.

Floyd became an accomplished author and professor. He is one of the most popular weird writers of Georgia, the South and the nation, and he traces the roots of his interest to a mysterious event that occurred on the night of his birth in 1947. "I was born the night the windows fell," he told *Augusta Metropolitan Spirit* for its Halloween special in 1989. "My mother and father lived in the country in South Georgia. It was an older home located in what could only be described as wilderness. You know, the dirt roads, the cry of wild animals at night."

He continued, "Well, my mother had been very ill with me. My father was on the back porch shaving when mother called to him saying she heard what sounded like several windows falling at one time in the house. She was alarmed, of course, and she didn't want my older brother and sister to cut their feet on the glass."

Floyd's mother wanted her husband to quickly gather up and dispose of the many sharp shards of glass panes that undoubtedly littered the floor of their home. It was a stormy night, with heavy rain and strong winds pummeling the rural structure, and certainly flying debris had shattered some windows.

"My father looks all over the house," Floyd continued, "but he finds no glass. He takes a lantern and looks outside, despite the storm and finds nothing. But three different times that evening the sound of breaking glass filled the house."

Floyd's mother had a very difficult delivery. The family took her to a hospital, where she nearly died from complications of the birth. "Two weeks later, the evening my parents brought me home from the hospital the unmistakable sound happened again—three times."

Floyd believes that "that eeriness, that strange sound…has haunted me all of my life. I guess I was destined to be a little weird I suppose. All I know is since then I have always been fascinated by unexplained mysteries."

Among Floyd's books are *Great Southern Mysteries, Ghost Lights and Other Encounters with the Unknown, In the Realm of Miracles and Visions* and *The World's 100 Greatest Mysteries.*

ATKINSON COUNTY

THE AXSON LIGHT

Georgia has a number of ghost lights. Some people believe that they are manifestations of the paranormal, while others maintain that they are the result of swamp gas, ball lightning or tricks of light. I opt for the former explanation.

South Georgia has competing spirit globes. Clinch County has the Cogdell Light, a more established event, which I described in *Weird Georgia* (2000). About ten miles north in Atkinson County is the Axson or Pearson Light. Although the named locations are seven miles apart, they are the same phenomenon. It is seen off U.S. 80 at the railroad tracks.

Legend has it that a man named Charlie Tanner was waiting for the train to arrive in the mid-1950s. As the locomotive approached, Tanner threw himself on the tracks to commit suicide. His head was severed, and the ghost light is Charlie's head bobbing about at night, searching for the remainder of his body.

In the 1970s, the dirt lane was a notorious lover's lane, attracting many young people to park and party. Local residents have fond memories of the light. Many saw it once, and that experience was sufficient; they never returned for subsequent experiences. The road was closed some years ago, but the light can still be seen beyond a barrier blocking access.

As "LuLu" wrote online, "Some were scared of the light and others of getting caught there!" Barbara flashed her lights three times, and the light appeared before her, "almost like either a train light or a conductor's lantern." Robyn, another witness, wrote that "no matter how fast you drive, you can't catch up with it. It only gets as close as it wants to."

Ashlee saw the light five times. On each occasion, it first materialized in the trees before moving forward and growing brighter. It would fade away and brighten repeatedly. Even the adults on the expedition "got majorly freaked out," she wrote. The light turned white, yellow and red.

Angie's experience was that the light appeared in the tree line and descended, coming "so close and getting so bright that it would hurt your eyes." The light "changed colors like crazy." Once she attempted to take a picture of the phenomenon, "but for some reason my camera would not work. I guess he [Charlie] didn't want his picture taken!"

"South Chit Chat" described an incident when she and her boyfriend visited the site. Stopped on the dirt road, "he told me look behind me and tell him what I saw…there was a man's head on the toolbox. I started screaming and he hit the gas.…I've never been back."

"Shayla_nikelle" saw the light on several expeditions, but at other times it never showed. "It appears at first as a small lantern light but it gets bigger and closer and even levitates. Some of the colors often change from green-blue-red and finally bright white and it disappears and reappears. It's really freaky."

On Facebook, Amy Ferris said, "It looked like a motorcycle light coming.…I was told if it got in the car with you it would burn you. Well it never got in 'cause we hit reverse and haul tailed it." Heather Thigpen agreed, writing on Facebook, "I have seen it many times, but never sat around long enough to ask any questions."

"Scared from town" described on the Ghosts of America website his efforts to observe the Axson Light. He had seen a red light several times, writing, "It will bounce around along the ground way down the dirt road then it'll get closer and be in the trees." He only witnessed the traditional light once. "It was about the size of a basketball and though it emitted no light, it was the texture of the light that got me. It was a hologram."

One variation on the ghost light theme has a child attempting to eat a candy bar and swim at the same time, drowning in a nearby pond, which gave rise to a different experience. Michael Griffin of Alma and a friend drove his Toyota 4x4 to the site and placed a Butterfinger candy bar on the hood, but that didn't work. Next the boys purchased a Snickers bar and placed it on the hood. After three minutes, they found "saliva and small children's fingerprints on the candy."

The friend who purchased the candy bar announced, "'I bought it, I'm going to eat it no matter what,' and he ate it," with apparently no ill effects.

BACON COUNTY

GHOST OF THE 'POSSUM, EATER OF THE DEAD

Harry E. Crews (1935–2012) was a noted novelist, playwright, essayist and short story writer. He taught at the University of Florida, and his papers are archived at the University of Georgia. Crews grew up poor in a one-room sharecropper's shack deep in the country. In 1978, he wrote an account of his early life, titled *A Childhood: The Biography of a Place*.

Crews spent considerable time with his best friend, Willalee Bookalee, the son of a black farmhand. He particularly loved Willalee's grandmother, called Auntie, a thin, elderly woman with a toothless mouth always filled with a thick cud of chewing tobacco.

Crews enjoyed eating with the Bookalees, particularly when they had 'possum, which his mother never cooked because she thought it would taste "like a wet dog smells." He explained that she refused to serve 'possum "because a possum is just like a buzzard. It will eat anything that is dead. The longer dead the better."

The first time he and Willalee watched Auntie gut a 'possum, she carefully removed the eyes, "which she always carefully set aside in a shallow dish."

After supper, Auntie said, "Come on now boy, and old Auntie'll show you."

"Show me what?" he asked.

Auntie carried the saucer containing the 'possum's eyes outside and then squatted to dig a hole in the dirt. Turning to Crews, she said, "You eat a possum, you bare [bury] its eyes." The boy asked why. "Possums eat whatall's dead. You gonna die too, boy." That stark statement startled Crews, but Auntie continued. "You be dead an in the ground, but you eat

this possum an he gone come lookin for you. He ain't gone stop lookin for you."

Auntie buried the 'possum's eyes looking straight up. "See, we done put them eyes looking up. But you gone be *down*. Ain't never gone git you. Possum he looking for you up, and you gone be six big feets under the ground. You gone allus be all right, you put the eyes lookin up."

Crews credited Auntie for teaching him "that some of what we discover is an unfathomable mystery that we can name—even defend against—but never understand."

BAKER COUNTY

THE CHURCHES ON HARD UP ROAD

Hard Up Road was popularly known as Seven Churches Road, although only three, sometimes four, remained. To relate the primary reported phenomenon of this lane, we turn to Sarah S. of Albany, who wrote a story titled "The Ghost of Seven Churches Road," incorporating the real-life stories of her sister, Erica, named "Phoebe" in her tale.

When Phoebe made her first excursion to Hard Up Road, she was armed with a rosary in her pocket. Near one church, she and companions found a baptismal font; above it was a large tree branch dubbed "the Gallows," for some unstated reason. Phoebe was framed in front of the font for a picture when she glimpsed a small girl dressed all in white. When the girl disappeared, Phoebe approached the font and saw her again, bearing "an angry look on her face." Looking around, Phoebe "saw people gathered round," and her rosary disappeared. A daylight search failed to locate it.

On another visit, the mysterious fourth church was located. That church had disappeared by the following day. The group found Bible verses written on the walls of one church, but each unaccountably contained numerous errors.

On one expedition, Phoebe and two friends decided to clock the time it took to reach Hard Up Road and the time required to get home. The drive there took fifteen minutes, but the return journey required forty-five minutes. As Sarah S. wrote, "Something wasn't right." Perhaps it was a space/time warp.

According to legend, Hard Up Road once had seven churches, each infested with paranormal activity; even the road itself was haunted. *Earline Miles*.

Phoebe drove the night they encountered a large black canine. Unable to stop in time, Phoebe ran over the dog. But investigation found no sign of the animal.

After returning from one expedition, Phoebe went to bed. Turning toward a window, she was terrified by the image of a large man. She screamed, and when a friend came running, she said, "I think we were followed home."

Local lore holds that a family of Satanists are buried in a cemetery near one church. Each member of that family had been born on Halloween, and all also died on All Hallows' Eve. At the cemetery, Phoebe grabbed a friend and ran away. When asked what was wrong, she replied, "I heard a voice yell, 'Get Out!'"

On another occasion, Phoebe and a friend visited Hard Up Road but were disappointed and relieved when nothing happened. However, the friend felt something burning the skin behind his ear. He checked the area with his hand, which came away with blood. Phoebe felt the same sensation, so they departed. At home, Phoebe's mother found both of them covered with scratches. By the following day, no evidence of the wounds remained.

In a story reminiscent of the dog encounter, one evening a friend was driving down Hard Up Road when an elderly woman walked in front of

the car and was struck. The driver immediately got out to check on the lady, but she had vanished. At home, he discovered bloody handprints on the rear of his car.

One prevalent story described a Bible lying on the pulpit of the third church. It could be picked up but became too heavy to carry before it reached the door, or the trespassers were not able to exit the building for some reason. One man actually managed to get the Bible into his car, but by the time he got home, the holy book had disappeared. Some saw a priest walking back and forth behind the pulpit.

A young man named Simon took fellow football players and a wheelbarrow into the church. They deposited the Bible in the wheelbarrow and started for the entrance, where the wheels broke. The intruders withdrew quickly but returned the next day to find the Bible on the pulpit and the wheelbarrow missing.

"Rosar113" grew up in the area and believed the girl in white was a flesh-and-blood resident, a mentally ill child who got out of her house at night and wandered the rural roads. In the mid-1980s, she managed to reach Cairo and was institutionalized in Thomasville for her own safety. That girl "believed herself to be possessed," Rosar113 wrote.

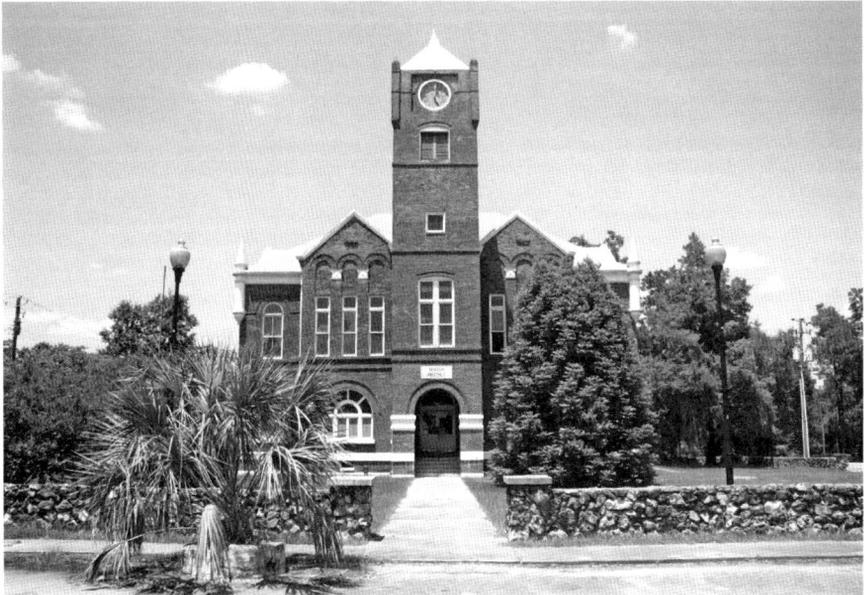

The forlorn courthouse in Newton, inundated by the Flint River several times, is thought to be haunted by its architect, J.W. Golucke. *Earline Miles.*

Bad history, which is all too common and too commonly believed, claims that this was the original site of Albany until an epidemic killed thousands. "Everything else has been stricken from record," it is claimed. In addition to the girl in white, assorted other ghosts and evil spirits were believed to stalk the lonely road, where Spanish moss draped off trees.

Jessica McDonald is devoted to Baker County and has an extensive website titled Southwest Georgia in Photographs, Rural Exploration of Southwest Georgia. She writes that the stories "are known as complete fiction to locals" but attract adventuresome teens and the curious. The three churches that she believes still exist on Hard Up Road are Mount Airy Baptist, Weldon Springs Baptist and Mount Ephesus. To combat trespassing and vandalism, one of the large bird hunting preserves in the area bought part of the road from the county, and half the lane was currently inaccessible.

For some reason, I felt led to personally investigate this story. Here are my findings. As indicated on my trusty 1985 county map, Hard Up Road originates to the north in Daugherty County, branching off from the intersection of GA 91 and GA 62. The road is ruler straight and paved, becoming a dirt surface at the Baker County line. Driving south, Ephesus Church is located on the left, followed by an unnamed cemetery on the right. Also on the right is Hard Up Cemetery, and shortly Bluesprings Church appears to the left. The road bends southwest, with Mount Airy Church on the right. The final sanctuary, White Corner Church, is also on the right just before the road terminates at GA 91.

In case you lost count, along Hard Up Road there are, or were, four churches and two cemeteries. Earline and I attempted to cruise Hard Up Road. At both ends, only a tiny portion of the road is accessible, just enough to show that the narrow road was spooky as hell, which does not prove that the road is or isn't haunted. The only accessible church is Ephesus, at the Dougherty County line. Don't violate the sanctity of that sanctuary. Also, do not trespass on Hard Up Road. Violators have been arrested.

One final point: If you Google this story, it always comes up as located in Albany but is clearly in northern Baker County. Georgia county maps never lie; they may mislead, but they never lie.

BEN HILL COUNTY

THE HEAVY BREATHERS

After experiencing supernatural events for thirty years, a Fitzgerald home owner contacted Crossing the Line Paranormal (CTLP) of Valdosta. "The claims include black shadow figures, apparitions, balls of light going through walls, hearing footsteps when nobody is home or awake, doors opening and doorknobs rattling violently," read the online investigation report.

Seven CTLP members formed three-person teams that entered the structure at different times. In the master bedroom, Team 1 "heard a loud bang" that originated from the bathroom. While recording EVPs in the living room, "Christa felt a breath on the back of her neck." As he occupied a kitchen chair, Jason "reported seeing a shadow figure block out the light from the living room window." All three members heard a loud tapping sound between the master bedroom and bathroom. When Philip approached the master bedroom from the dining room, "the door suddenly and swiftly opened." Team 1 also heard a sigh from the kitchen.

During Team 2's time in the living room, Victoria experienced "a breath on her neck" exactly where Christa had. Shana also "heard a moan in her ear." As a flashlight lay on a table, the light "flickered on and off." When Victoria asked the spirit "if it had a message to send on," the flashlight flickered again. Unfortunately, no message was received.

While Team 3 explored the house, Philip experienced the breath on his neck.

As each paranormal event occurred, the teams immediately investigated and found no explanation for any incident, including one EMF spike. EVPs included murmuring, whispering, laughter, breathing, dragging and loud bangs; some were recorded while investigators were talking, and one whisper said, "Get out."

BERRIEN COUNTY

THE HOUSE IN RAY CITY

Jones Street in Ray City has an extremely haunted house, according to the Southern Ghost Hunters (SGH). On its website, the incident is recorded as case no. 35.

The century-old home had been recently renovated, activity that often brings about the wrath of ghostly inhabitants. The homeowner, his relatives and paranormal investigators saw the apparitions of two different male ghosts. Shadows are often seen traveling throughout every part of the house. Objects are moved about—and right in front of the owner, in more than one case.

Ghosts often roam beneath rows of ancient oaks and decayed buildings of old plantations. *Earline Miles.*

"Doors open, door handles rattle, and there are bangings and scratchings happening in different areas of the house, keeping the owner awake during the night," the SGH's case report stated, "and there have been large temperature drops, and anomalous EMF readings."

The house was so paranormally active that veteran SGH investigators had a "hard time keeping up with all the activity, and keeping their wits about them."

The first update on the initial case report stated that the owner had moved out and been replaced by new residents, who departed within two weeks. A second update noted that several families had moved in and out of the house during short periods of time.

In one photograph, a mist formed around the legs of a dog, which seemed alert to the presence of a supernatural experience. In a second picture, the mist had enveloped the animal, which looked truly scared.

BRANTLEY COUNTY

BAD DIVORCE VIBES?

In 2003, a man constructed a new home in Nahunta for his family. Unfortunately, six years later, the couple divorced, and the wife received the house in an acrimonious settlement. At about that time, paranormal events began to occur throughout the structure.

The family heard footsteps traveling up and down the stairs to an attic bedroom, where the water heater repeatedly adjusted itself and the door to the attic swung open by itself after a deadbolt lock was opened. A daughter was so disturbed by noises emanating from that space that she needed a sound machine making white noise in order to sleep.

A son, who was once scratched by an invisible entity, saw a face in a window while outside. He also heard sounds from within his closet.

One corner of the master bedroom frightened the woman of the house, who felt like she was being watched. She also heard music in the bedroom and three bangs or knocks on the window.

Kitchen cabinets opened and closed themselves, and a friend witnessed a person inside the "beauty" room. From the driveway, the sound of a bouncing basketball was heard, and at times, a "strong beautiful aroma" was detected.

The owner requested the services of Ghosts of Georgia Paranormal Investigations (GGPI). On July 16, 2011, five members arrived to study the situation, joined by the owner and her cousin. The ghost hunters brought a digital camera, four video recorders, five EMF meters, three audio recorders and two thermometers. They established base readings throughout the house at 8:00 p.m. and investigated until 3:30 a.m.

Numerous ghost stories have been told by people who lived in old houses. The ghosts seemed tied to the building, the land or a family. *Earline Miles.*

Team 1 heard popping in the kitchen, Team 2 witnessed an anomaly at the water heater and Team 3 heard an "alarm." Two other teams found nothing significant. However, their personal experiences were more substantial. Outside, Larry Conley felt a cobweb, often termed an "energy web," on his face. He was unable to remove it, but it disappeared on its own.

Ed Laughlin felt something touch the top of his head in the "beauty" room, and in the master bedroom/bathroom, he felt nauseated, "jittery, and cold inside." Leaving the area, he felt better, but upon returning, the sensations resumed. Suddenly, as he sat in the room that affected him, he felt better. Describing the experience to Beth Peters, she told him that "the female spirit she was picking up had just left the room."

While in the attic bedroom, Laurie Filsinger had a feeling of being watched and "felt very strongly that something had moved up next to me very close on my left side." As she sat on the bed during an EVP session, she "felt like my left foot started to vibrate" for several seconds. She had never experienced such a sensation, and then she discovered that her left shoe had been untied. She also "felt like something lifted a tiny section of my hair up near the front of my head…then let it drop."

Beth Peters had an interesting psychic experience. While in the master bedroom, she "was contacted by [the client's] friend that passed." Ed also felt the presence. Beth discussed this with the owner, who "was able to confirm all the signs and symbols given to me by her friend and then a message for her too." Beth felt another presence in the bedroom.

Christine Riley "heard a male disembodied voice about two minutes apart." In the attic bedroom, "I again heard the same sounding male voice… like he was making a long deep exhale."

GGPI had exacting standards. What the members discovered that night did not rise to the level of a haunting. However, because of "the numerous EVPs, personal experiences, and the claims of activity experienced by the client we feel that there is paranormal activity in the home."

The organization recommended a second investigation to gather additional evidence and to see whether the initial phenomena could be repeated.

BROOKS COUNTY

WHOSE CHILD WAS THAT?

In the early 1980s, Edgar A., his wife of three years and their two-year-old son and infant son were living near Pavo in a mobile home that his parents had found for them.

"It was a cold night in the dead of winter," Edgar wrote on the website About.com in March 2013 in a submission titled "Little Child Ghost." The central heating unit was broken, and the house was warmed by a kerosene heater located in the living room. A sheet hung between the living room and the hall to keep the heat in their primary living space. Edgar was in a back bedroom, while the children were in the living room.

According to one of many legends about Spook Bridge, a husband threw his wife off to her death, but she returns nightly. *Melanie Miles Barker.*

"I was coming to check on them, and at the same time my two-year-old was headed toward the back of the house. We met at the hanging sheet, and as we passed each other I playfully grabbed my son by the head through the sheet. As I passed the sheet to the other side, I noticed my son was still sitting on the couch!" Edgar found the experience disturbing. "I am convinced that was the ghost or spirit of a young child that I touched on the head," Edgar thought.

In the additional two years the family lived there, the couple often "heard the sounds of children playing," primarily from the back bedroom. Under that bed was a large red stain on the carpet that they thought was blood. "We learned later that someone had tragically died there," Edgar said.

BRYAN COUNTY

THE SPIRIT OF ROOM XXX

On June 5, 2009, an anonymous website poster was driving home to Maryland following a trip to Florida and decided to stop for the night in Richmond Hill. He checked into a Days Inn, noting that it was a renovated older hotel; the receipt still had Scottish Inn printed on it.

After inquiring of dining opportunities, he ate at an established local seafood restaurant, Love's, where he learned that scenes from the movie *Forrest Gump* had been filmed there. Returning to his hotel room, number XXX, he settled onto the bed to watch TV until he fell asleep, his accustomed routine.

In the early morning, between 1:00 a.m. and 3:00 a.m., he was "woken up out of sleep by something unseen rapidly pushing on the bed next to me like someone was intentionally trying to wake me up," he wrote on Shadowlands. "As I woke up, I felt a cold atmosphere slowly flow into the room. As I was startled by this, I hesitated for a few seconds to roll over to see what was doing this, but when I did, I saw the mattress shaking. I turned my head back, and saw a bluish, globe-like, object floating in the air at the foot of the bed, that was slightly opaque. The orb lasted for about ten seconds, until it dissolved near the ceiling." Puzzled, he turned on the light and TV until he again fell asleep.

CALHOUN COUNTY

THE TRANSPLANTED HAUNTS

Ten years ago, it occurred to me to collect a ghost story from each of Georgia's 159 counties, plus 2 counties dissolved nearly a century ago. I never imagined it would be such a difficult mission. I experienced considerable frustration finding a ghost story for Calhoun County. When I eventually located one, it had moved two hundred miles north.

Dickey, located in northwestern Calhoun County, was settled along Pachilla Creek and currently has a population of forty-seven. The Dickey House, a grand plantation dwelling dating to 1840, has fourteen rooms and 6,250 square feet. Constructed in the Neoclassical style, it has twin staircases leading to the entrance, which has Palladian arched windows. Descendants of the original owners lived in the grand home until it was moved in 1962.

Stone Mountain Park, centered on the giant carving of three Confederate heroes—Jefferson Davis, Robert E. Lee and Stonewall Jackson—was established on February 21, 1958. A major attraction is the Antebellum Plantation, created by antiques authority Mrs. Charles McWhorter and opened on April 6, 1962.

Twenty historic structures, dating between 1790 and 1875 and gathered from across the state, were dismantled, transported to Stone Mountain, reconstructed and restored. An impressive collection of period furniture and decorations displayed in these buildings represent the times of those who lived and worked in them.

In addition to the Dickey House, there are other historic houses and appropriate outbuildings. The oldest, dating to 1790, is the Thorton House,

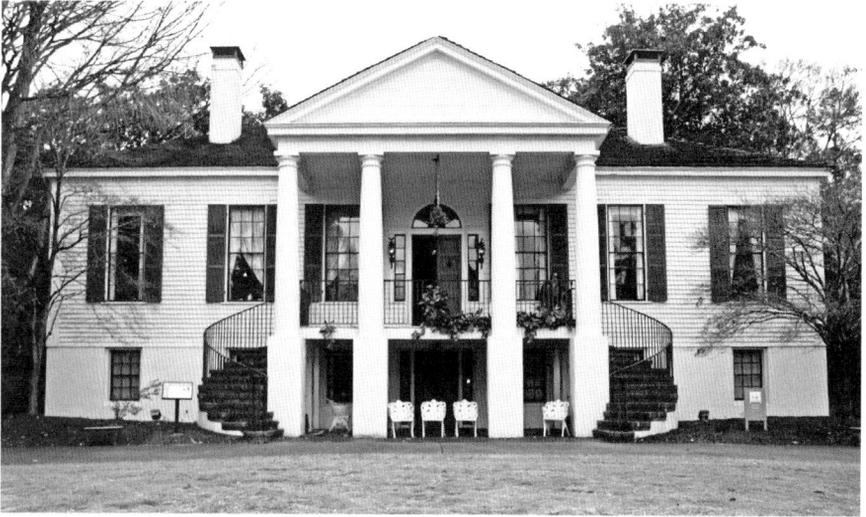

A woman can be seen peering from the second-floor windows of the Dickey House, transported from Calhoun County to Stone Mountain. *Earline Miles.*

transferred from Union Point in Greene County. An overseer's house came from Kingston, in Bartow County. Two clapboard slave cabins are from the Graves Plantation in Newton County. There is a general store from the 1830s, a cookhouse, a smokehouse, a carriage house, a one-room school, a doctor's office, a barn and storage cribs. The grounds feature a gazebo, formal gardens and a vegetable garden.

At the park are animals to feed and pet, Civil War reenactors (who often seem to attract ghosts), storytellers, balladeers and craft and cooking demonstrations offered by costumed workers.

Civil War reenactors camping on the large lawn fronting the Dickey House have often seen a woman standing at the second-floor windows peering out at them. On each occasion, the building was empty of all living beings.

Reese Christian, author of *Ghosts of Atlanta: Phantoms of the Phoenix City*, related a number of stories about the Thorton House.

Evidently, a preteen girl, whom some call Sarah, died in the house, her spirit lingering still. She has often been witnessed at the top of the stairs and sometimes on the steps. Teenage girls have had their hair playfully pulled.

Park historian Cindy Horton was intrigued by a bright orb she observed floating at the head of the stairs. Thinking that it was a summons or invitation, she walked up and found a broken window in what was a child's room, possibly belonging to the little girl. She wondered if the ghostly kid

was protecting her room by pointing out a problem that needed to be fixed. Perhaps that is why Sarah also regularly blows out all the candles in the house, all while no breeze is detected.

A real five-year-old girl was ascending the stairs with her mother when she suddenly stopped, said "Okay" to no one and scampered down the stairs. The mother continued to the girl's room and called down to her daughter, inviting her upstairs to see it. The child's chilling reply was, "The lady on the stairs told me not to."

April and her mother were touring the Thorton House one day near closing time, she informed Ghosts of America, when her mother saw a young man standing on the stairs. Noting his period clothing, she thought that he must be a tour guide, but she glanced away for a moment and he disappeared. She believed that the boy was about sixteen, his khaki-like pants, suspenders and gray shirt marking him from the period between 1880 and 1920. In an upstairs bedroom, April sensed his presence, and her mother feared he might shove her down the stairs.

As they toured the grounds, both felt that this male entity "was glaring at us from the windows." April felt that the ghost was angry at what he considered intruders, which numbered hundreds each day. She thought he didn't understand or even "know that he was dead."

While Keshia was on a class field trip to the planation, she and others heard a voice saying, "Go away," before seeing a little girl within the building. When Spook Hunters investigated on June 10, 2004, the members felt a presence at the top of the staircase.

It appears that Stone Mountain is haunted not only by the ghosts of the Confederacy but also by spirits assembled from around the state.

The ghost of a girl has often been experienced in a Calhoun County house preserved at Stone Mountain. *Earline Miles.*

CAMDEN COUNTY

CUMBERLAND ISLAND'S SPOOKS

In April 2002, Yvonne of Savannah wrote "Castle of Sprits" about a recent trip to Cumberland Island taken by herself, husband Shane and her sister. As they approached the ruins of Dungeness, the two women heard the sound of excited voices, and Shane stated that he was "spooked" after "he had seen a very tall man in a brown shirt going by very fast, and had called to him and that the man had disappeared in front of his eyes."

Two years later, Yvonne, Shane and their friend Stefan were hiking on the island. The heat was suffocating, and Yvonne prayed for a breeze and relief from the sun and "added that if any spirit wanted to show itself we would welcome it." At that moment, a large monarch butterfly appeared

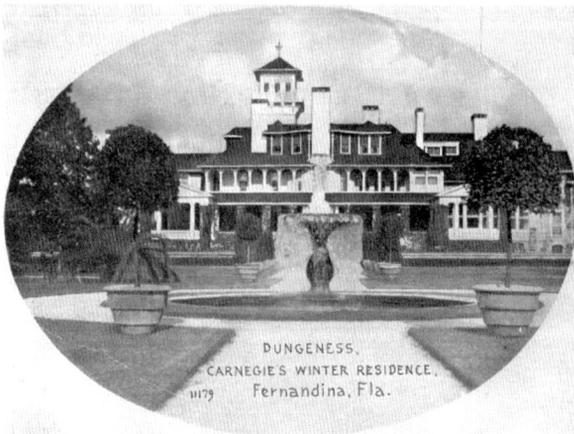

Ghosts inhabit Cumberland Island. These are the ruins of the once great mansion Dungeness. *Author's personal collection.*

over their heads and led the way down a path. A breeze started to blow, and clouds obscured the sun, precursor to a summer storm.

Suddenly, "down the path I saw a figure of a person, tall and thin, dressed in a light brown long sleeved shirt and going extremely fast." After a moment, she asked Stefan if he had seen anything. "Thank God!" was the response. "You saw it too!" Thinking back, Yvonne realized that the butterfly had disappeared at the figure's appearance, which also marked the third of Yvonne's requests.

I am still waiting for sightings of Henry "Light-Horse Harry" Lee's ghost searching the island for his original headstone, left as a memorial when Virginia moved the body to the Lee Crypt at Washington and Lee University in Lexington, Virginia. Lee was a prominent figure of the Revolution and father of famed Confederate leader Robert E. Lee, who twice visited the Georgia grave.

CHARLTON COUNTY

DEAD MAN SEARCHES FOR HIS LOOT

Race Pond is located in Charlton County near the Okefenooke Swamp, thirteen miles northwest of Folkston. The story goes that in 1836, a contingent of soldiers, positioned to block raiding parties of Native Americans from exiting the swamp to attack settlers, constructed a horse racetrack around a perfectly circular cypress pond. The Atlantic Coast Line Railroad later extended a line through the community.

An old machinist, an Irish immigrant with the unusual name of Thomas Thomas, had established his home in a house at Race Pond. The peculiar fellow often told his neighbors that after his death, "he would return to this world and take possession of his money."

This sign discovered at the southernmost border of Georgia could symbolize death, but is that the true end of the line? *Jim Miles.*

Old and new Georgia homes are plagued by the appearances of ghosts. In Charlton County, a deceased resident searched for his treasure hoard. *Earline Miles.*

Acceding to the *Savannah Morning News*, in a report bylined Waycross and dated March 6, 1891, Thomas Thomas did die, and shortly afterward "the people in that neighborhood are very much disturbed by mysterious lights, which appear and go on suddenly, at a certain hour every night" within the abandoned house. The lights appeared regularly, and locals "believed that the house is haunted by the old man's spirit," endlessly searching for his treasure.

CHATHAM COUNTY

NATIVE AMERICAN SPIRITS REMAIN ON THE COAST

In his book *Danny's Bed*, noted Georgia ghost author Al Cobb related a story about the spirits of Georgia's prehistoric residents lingering today. It starts with Natalie and Johnny, a young couple separated by his untimely death. Johnny soon returned in a dream and promised to protect Natalie. Several people detected his presence prowling his former offices at night.

Time passed, and Natalie fell in love with Ben, a realtor, and the couple built a home on Modina Island. Unknown to Ben, Natalie placed the bed in which Johnny had died in their bedroom. From the beginning, Ben felt breathing on his neck at night. One morning, Johnny struck Ben and started dragging him from the bed. Natalie then confessed the secret of the bed, which was quickly given to his son in college. The son soon rejected it because he also felt the phantom breath.

Natalie conferred with a psychic-medium, who came to their home to conduct an exorcism that would enable Johnny's spirit to move on to the next spiritual plane. When the psychic opened a passage to that realm, a dozen spirits of Native Americans sought entrance, a request that, for some strange reason, was granted.

Natalie and Ben went their separate ways, but Ben kept the house, living alone with his dogs, a pit bull and a German shepherd. The brave, fierce canines refused to venture upstairs without Ben, who constantly felt like he was being watched. This feeling was so intense that he installed an alarm system and additional lighting and started carrying a pistol. Cleo, Ben's housekeeper, saw the ghosts of Native Americans, dressed in traditional

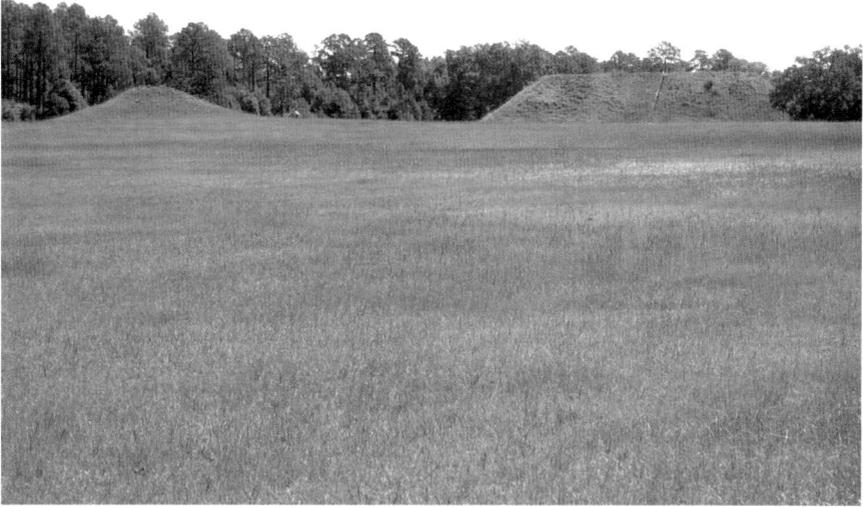

After homes were constructed over ancient mounds near Savannah, one house attracted the ghosts of Native Americans. *Earline Miles*.

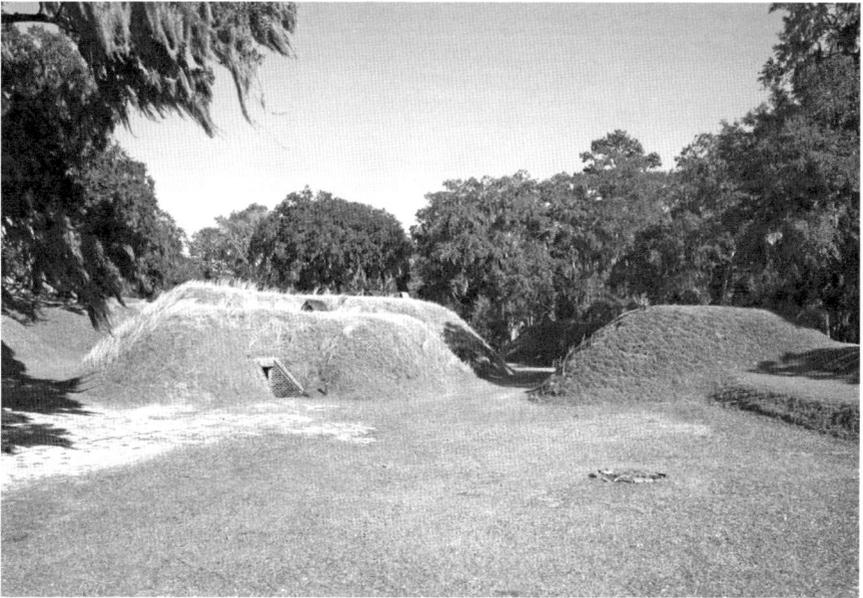

Confederate Fort McAllister was attacked several times. Its headless commander, John Gallie, has been seen on the earthworks. *Jim Miles*.

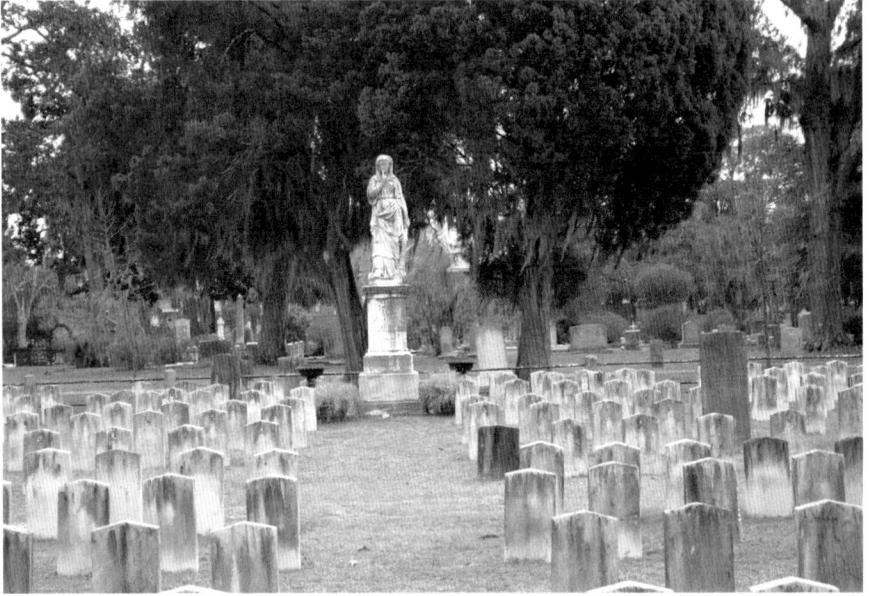

The Silence Monument watches over Confederate graves in Savannah's Laurel Grove Cemetery, where people sense the presence of soldiers. *Jim Miles.*

garb, strolling on the dock as dusk fell. While working in the kitchen once, she caught sight of a dark, headless spirit in a corner.

Research revealed that the ground around the house was the site of burial mounds. The natives who lived on the island hunted and fished for thousands of years before James Oglethorpe arrived. It is felt that their spirits, while disconcerting, apparently will not molest modern inhabitants if their ancestral holy land is respected.

CLINCH COUNTY

A CELEBRATED HAUNTED HOUSE

A correspondent identified as "Alpha" in the *Savannah Morning News* on October 23, 1888, related a first-person account of a haunted house at Homerville. While stating his lack of belief in ghosts, Alpha referenced a certain house that no one can live in because "they are aroused from their slumbers at night by a noise that is calculated to excite fear and suspicion. This house has been examined thoroughly by different parties, and watched very closely to discover the cause of this noise, but no one has ever been able yet to detect it."

In 1888, a newspaperman and others investigated a "haunted house" in Homerville. They shortly learned why no one would live there. *Earline Miles*.

Alpha and others entered the house on the night of October 21 and emerged "fully satisfied that there is a mystery." According to the reporter, the "strange noise will go from one room to another in the twinkling of an eye; it has been followed from one room to another and nothing yet has ever been seen." Homerville's "most prominent citizens" attest to the mystery, said Alpha, and he challenged any doubters to conduct their own investigation.

CLAY COUNTY

SPOOK HILL

In both my *Weird Georgia* books (Cumberland House 2000; Sterling 2006), I described various magic hills found across Georgia, but until now, I had never addressed Spook Hill (Magic Hill/Gravity Hill/Magnetic Hill), found in southwest Georgia's Clay County.

At these spots, located throughout Georgia and doubtless the rest of the world wherever wheeled vehicles are employed, motorists stop at the apparent "bottom" of a hill, turn off their car's engines and shift into neutral gear. Their cars are then magically propelled "up" the hill. Balls and other round articles are similarly affected.

Folklore explanations are numerous—children killed in a school bus accident, motorists mangled in terrible wrecks or other ghosts and even witches pushing the vehicle up the hill just to be helpful. Legend swears that you will often find fingerprints (especially small ones from little children's hands) on the rear bumper or trunk of the car, particularly if you coat the car with talcum powder. Some of the little tykes will also partially consume proffered candy bars.

In reality, the true explanation of the phenomenon is an optical illusion in which the surrounding landscape makes it appear that the road slopes up; in reality, the pavement is descending.

The curious come from near and far, but primarily locally, to experience the phenomenon and get a few cheap giggles. Children and teenagers are particularly amused by the experience.

The family of Brent Christian stopped in Clay County on their way to the Sunshine State. "It was very quiet and eerie," Brent wrote on the Roadside America website in 2007. "Then all of a sudden the van started to creep up the hill and gain speed. It was the best attraction on our way down to Florida. The kids will forever remember Gravity Hill."

"Reflmao44" also found that his car moved upslope. "ROLL UP!" he emphasized, "and on and on for a few miles."

Clay County's Spook Hill is located between Fort Gaines and Georgetown. From Fort Gaines, travel north on Route 39 for 7 miles to the intersection with County Road 135 at Days Crossroads. Turn east onto 135 and cross County Road 50, and at 0.7 miles, at the "bottom" of a hill near the curve sign, you are there.

Idiot Alert: This is obviously a dangerous experience, and you do it at your own peril. If you must go, turn on your headlights and emergency flashers and keep a sharp lookout on the road in both directions. A nighttime visit invites increased danger. Use your brain and don't become a posthumous recipient of the Darwin Award.

COFFEE COUNTY

THE HAUNTED CHAMBER OF COMMERCE

In 1912, John Marshall Ashley constructed a lavish Neoclassical house as a wedding present for his wife, Ada. Unfortunately, the beautiful house was not meant to be a happy one. After their twenty-two-month-old child died in 1918, John raised his hands to heaven and cursed God. Several days later, he was struck down by a stroke and died.

Ashley married again, a man named John Slater, a prominent politician considered a good candidate for governor. However, Slater suffered from deep depression. When Ada returned home from church one Sunday in the spring of 1930, she could not locate her husband. She searched the house to no avail and then opened the door to the attic, where she found the thirty-eight-year-old Slater hanging from a rafter by a rope he had fashioned himself. Ada lived a long if not happy life, dying in her bedroom during the 1970s at age ninety-two of natural causes.

The mansion was obtained by local government and put to good public use as the local chamber of commerce. It retains the lavish touches, like a seventy-foot pastoral mural on the dining room wall, a piano dating to 1862 and ornate molding and woodwork.

The Ashley-Slater House is considered the most haunted structure in Douglas. Employees and visitors report hearing footsteps when no one is present but themselves, cold spots, shoves down the stairs and pressure on the shoulder. Many feel they are being watched and smell cigarette smoke from Ada's old bedroom; the cursed lady was addicted to tobacco. Office machinery switches on and off, and the elevator operates at random, sending

In the Ashley-Slater House in Douglas, machines activate, the elevator operates itself and employees and visitors hear footsteps. *Earline Miles*.

itself on a journey from floor to floor, although no mechanical flaws can be found. The after-hours security system senses activity within the building and sounds an alarm, but police never find anything amiss. Some say that every fourth month, the souls of all those who died in the house appear, and others have seen the figure of a man in windows late at night. Paranormal researchers have captured EVPs and orbs. Few workers will remain in the structure after dark, and many would rather not venture down to the basement, where they are overcome by feelings of fear.

The Ashley-Slater House is now a welcome center and museum, at 211 South Gaskin Avenue, Douglas, Georgia, 31533; (912) 384-4555; http://www.cityofdouglas.com/index.aspx?NID=122.

COLQUITT COUNTY

WHO'S THERE AT THE OLD BED-AND-BREAKFAST?

The grand home at 704 Third Street Southwest in Moultrie, constructed in 1905, was once a fine bed-and-breakfast establishment called the Barber-Tucker Inn. The owners invested $1 million in renovations and offered seven guest rooms in the 8,100-square-foot structure, plus a carriage house. The building has 12-foot ceilings, an ornate stairway, beautiful woodwork and moldings, large white columns and a wraparound veranda. Unfortunately, after ten years of operation, the Barber-Tucker Inn closed.

On June 1, 2008, "msfitzga" submitted an online review of her stay at the inn to TripAdvisor and titled it "Beautiful but haunted." She and her husband were in Moultrie on business and considered moving to the community. She described the building as "a fine old southern house with a quiet timelessness."

The couple spent a long day in meetings and retired to their "beautifully appointed room" for a night of sleep "on the sumptuous beds." They occupied a room at the rear of the house, while their twenty-one-year-old son stayed at the opposite end of the hall.

"At 2:30 in the morning there was a violent shaking on our door knob!" msfitzga wrote. "Not the sort of jiggle when someone makes a mistake on which room they are in, but a powerful clanging as though to rip the knob off. I sat bolt upright in bed and called out, but no answer. Then I leapt out of bed to open the door fearing our son was ill and unable to answer…no one there."

A woman staying at this Moultrie house twice witnessed violent assaults on their doorknob, although no culprit was visible. *Earline Miles.*

After attempting unsuccessfully to awaken her deeply sleeping husband, she returned to bed. "Just as I lay back down," she continued, "it happened again! This time I flew out of bed and opened the door. No one. I ran down the hall to check on my son who was also awake. He hadn't heard anything but complained that he hadn't slept a wink the whole night. Weird! This boy has slept through brass band parades!"

"I wouldn't hesitate to stay again at this fine old B&B," she concluded, "but I sure would like to know who rattles the door knobs!"

COOK COUNTY

POLTERGEIST 101

T he family had just moved into a house on Parish Avenue in Adel, wrote Angela on Ghosts of America. One night, after she and her husband had the children sleeping soundly in their rooms, they slipped into their own bed. As she moved to turn off the lights, "We heard dishes shatter."

An alarmed Angela rushed through the kitchen and into the dining room but found "no broken anything anywhere." The children slept soundly, and had any been up getting into mischief, she was certain she would have heard their footsteps on the wooden floors. Puzzled, she returned to bed.

For some unknown reason, ghosts love to be seen ascending or descending stairs or simply standing on the landings. *Earline Miles.*

In the morning, she found peanut butter smeared on shelves, but more disturbing were claw marks that had been dug into the kitchen table. No answer to these troubling events was ever discovered, nor was this the end of the problem.

She and her husband had difficulty sleeping because of a feeling of being watched in their room, and "our dog sits at our dresser and growls and then hides in the bed." Decorations have dropped from walls in the night, and one child had even "seen things."

In attempts to oust their resident spirit, she had prayed and thrown salt, to no avail. She was becoming "very upset" with the situation. Although no one has uncovered any troubling history of the area, residents told Angela that previous tenants had never remained long.

"Not happy with it," Angela concluded, "but am damn sure not leaving. I love this house."

CRISP COUNTY

SWAMP GAS, WILL-O'-THE-WISP OR BALL LIGHTNING?

I had hoped for a strong Crisp County ghost story because that is the ancestral home of my wife's mother, Sarah Childers Landers. I had a lead at a church reunion (Ebenezer Baptist Church, always great food and good fellowship), but it turned out that each person merely knew of something experienced by someone else. What I heard a dozen times was, "No, that wasn't me, that was [fill-in-the-blank cousin, sibling, aunt, uncle, granny, papa]." At the frustrating end of the trail, Uncle Vernon Childers told me that he had walked into an unoccupied family house and found a washing machine running, which he firmly attributed to defective electrical wiring. Rats, as Charlie Brown always said.

A year later, my wife and I were in Macon visiting her cousin, Quinton Childers, who did our taxes. Earline was inspecting a bookcase in his office and handed me a spiral-bound book titled *Sparks from the Flint*. It was published in 1976—obviously a bicentennial project, put together by the Independent Study Program at Crisp County High School and certainly inspired by Eliot Wigginton's *Foxfire* books. Students had fanned out across Crisp County to interview older residents and then transcribed the tapes and compiled the book. In one chapter, labeled "Tall Tales," I found what I wanted. This may not be a family story, but I did get it through relations. Thanks, Quinton.

When she was a child, Mrs. D.O.E. Cox's family constructed a home located one mile from their earlier residence. Each day, one of the kids had to lead their horses to the facilities at the old home place, on the way crossing a small stream via a footbridge.

One boy constantly failed at this chore. Along the route, "he would hear pots and pans and things rattling, and he would get scared and come back home," the account read. "When he looked behind him, there would be a ball of fire, and the faster he would run, the faster that ball of fire would go. But when he would get to the foot log and go across the water, that ball of fire would disappear."

One day, when the lad returned home, his father asked if he had completed the task. The boy admitted to turning back, saying, "You ought to heard that racket down there."

The child then heard those horrible words: "Boy, I'm gonna get me a switch and wear you out if you don't get those colts back."

The boy attempted to defend his actions, saying, "Well, Pa, I'm telling you right now, you go yourself and when you start back, that fire will follow you. It looked like a cat's head. The faster you come, it's right with you, it's right behind you. And when you get on that foot log, coming across the water, that thing disappears."

The story may be dismissed as typical behavior by swamp gas or some other naturally occurring phenomenon like ball lightning, but this mystery appeared far too regularly and behaved predictably, and it came with bizarre sound effects. True paranormal activity often recurs, and bodies of water can act as barriers to it.

DECATUR COUNTY

THE SUBTERRANEAN GHOST CAT

"I have collected literally hundreds of first-person ghost experiences from across the South," stated author Randy Russell, and he researched three hundred years of southern folklore.

This "ghostlorist" from Asheville, North Carolina, is an academic folklorist who has published ten books, consisting of southern ghost stories and novels, and presents ghost lore programs across the South. In his book, *Ghost Cats of the South*, Russell stated his belief that cats adopt a home and family forever, literally, and he believes in cat ghosts, both good and evil. He presented twenty-two tales in *Ghost Cats of the South*, including one from Georgia.

When someone mentions caves in Georgia, the automatic assumption is that they are located in the mountains to the north. Few realize that one of the South's largest caverns is located not far from our border with Florida. In South Georgia's Decatur County is Climax Cavern, a seven-mile-long cave carved from the limestone of an ancient sea floor formed millions of years ago.

In 2003, one member of a spelunker team drowned inside the cave, and there are dark rumors of other deaths stretching far back into the past. This dangerous cavern is closed, and violators are persecuted. Don't even think about exploring this subterranean marvel.

It was the height of summer, the worst heat yet. David Hyatt worked his job during the cooler evenings, and the steaming days were the only time he had with his girlfriend, DeeAnna. After considerable thinking, David devised a plan. He packed up for a picnic, with flashlights (in the middle of

the day), and headed to Climax Caverns for a midday picnic/camping trip. He knew of a secret entrance.

DeeAnna was apprehensive as they negotiated the narrow entrance into the first large room. A cousin had instructed David to avoid a small room containing a wooden bed frame, on which lay an old skeleton, perhaps dating back to the Civil War.

Suddenly, DeeAnna screamed, dropping her flashlight and grabbing David. She had been startled by the appearance of a cat, "a funny looking thing," with eyes shining in the flashlight beam and its spooky hair glistening like ice. The cat walked slowly along a ledge in the passage, eyeing the intruders, before leaping off and vanishing into the darkness of the cave.

"It's just a cat," David reassured his girlfriend, and she replied, "It looked sort of strange." As they continued to creep through the cave, she added, "I think that cat wanted to show us something."

They soon found themselves at the entrance to a room with a wooden bed placed against the wall. Curiously, the bed was made, and the cat was curled up near the end. DeeAnna was fascinated by an antique doll laid on a pillow on the opposite end. She reached for it.

DeeAnna couldn't see the sight that horrified David. Lying beside the doll was a little girl, clad in a long white gown, with her hands crossed over her chest. Her exposed skin was covered with open sores. There was old, dried blood at one corner of her mouth, her closed lips were blue and her yellow hair had separated from her head. Suddenly the girl's eyes opened, exposing black, empty cavities.

It was David's turn to scream, frightening the cat away, its passing marked by a blast of frigid air. DeeAnna also yelped, but only because she had been startled. As David announced, "Let's go," DeeAnna turned to the doll and picked it up. David hurried them out of the cave, the heat welcome for once.

"What was that room?" DeeAnna asked. "It looked like a movie set." She wanted to return and take pictures of the scene, but David said, "I'm never coming back." DeeAnna asked if it was because of the cat.

"The cat's not real," David stated. "It was just something…something we saw. The cat's not real."

"Okay," DeeAnna humored David. "If you say so." She was only concerned about the antique doll, with its wooden head, painted facial features, carefully arranged human hair wig and cloth body; its muslin dress was embroidered with red flowers and yellow scrolls. The doll seemed to be brand new, although the style looked to date from the 1860s.

David quickly repacked his Toyota pickup truck, while DeeAnna admired her new doll. She thought that David must have bought the doll and placed it in the cave for her to discover.

"Did you do that, David?" she asked. She peppered him with additional questions about her gift, but to each one, David responded with a terse, "No." Then he heard the cat meow; it seemed to be following them from the cave. David hustled his girlfriend into the truck, cranked it up and turned the air conditioner on high. When he glanced at her, she didn't seem bothered by the extreme heat. She showed not a drop of sweat, while his clothing was soaked.

DeeAnna reached forward and turned the air to its lowest settling, and when she kissed David for her gift, her lips were cold. As she touched him, her hand felt like ice. When she reached and turned the AC off, he rolled his window down. Sweat ran down his body, but DeeAnna had goose bumps, and she "was singing some sort of soft lullaby to the doll in a little girl's voice." David couldn't distinguish the words.

When DeeAnna announced her wish to go home, David glanced at her, realizing that her teeth were chattering, her cheeks flushed and her lips pale. David suddenly remembered that the cat had been frosted with ice. "Did you touch the cat?" he asked.

"She touched me, Daddy," was the creepy reply. "She's my kitty. I hug her when I want to. You gave her to me, Daddy."

David slammed on the brakes, got out and ran around to the passenger side. Opening the door, he knew that DeeAnna's condition had been caused by the doll. He wrenched it from her grasp, threw it away, got back in and drove away.

With DeeAnna's trance broken, she realized that she was freezing and started rubbing her arms and legs. David turned the heater all the way up. He felt as if he were dying from the heat, but DeeAnna said, "I'm freezing. I'm colder than the dead."

She was doubled over, seeking heat. David stopped and pulled her from the truck, hugged her to share his warmth. He tried to make her walk, but her feet were numb from the cold. David grabbed a sleeping bag from the truck bed and zipped her up in it. Nothing seemed to help. Her skin was white, an icy glaze coating her upper lip, and she breathed frost in the hot air of the truck. She looked like the cat they had encountered inside the cave.

Nothing helped, so David quickly drove to the nearest hospital. DeeAnna was rushed to a treatment room, and David was instructed to sit in the lobby.

Within ten minutes, a doctor emerged and gravely informed David that DeeAnna had died of hypothermia.

David spent considerable time thinking about the experience. The little girl must have had a severe fever from some disease, he concluded. Her family had taken her into the coolness of the cavern, with her cat and favorite toy, even carrying the child's bed inside. There she had died and was left in peace. Her faithful cat stayed with her, and its spirit remains still.

In case you were curious, there are many cat and dog ghost stories. For a different Georgia ghost cat, check out Tom Cat, a mascot killed in the Civil War during a Union bombardment of Fort McAllister, related in my *Civil War Ghosts of Central Georgia and Savannah*.

DODGE COUNTY

A GHOST WATCHED OVER THE CHILDREN

Mrs. Ethel King is a legend in Dodge County history and a ghostly figure today. The widow lived on the outskirts of Eastman. One stormy day in 1927, she sat beside an open window while knitting a shawl. God apparently decided that it was time to call Mrs. King home to her heavenly reward and dispatched a lightning bolt through the window to claim her soul. However, maybe it was nature rather than a divine strike, for research revealed that four other people have been killed by lightning within a hundred yards of that location.

Mrs. King's home was demolished around 1950, but a replacement residence was soon constructed on the same site and incorporated lumber from the earlier structure…as well as perhaps Mrs. King's spirit.

In 1962, Robert and Betty Kight bought the house and raised their children, Robert Jr. and Elaine, on the property. Soon, Mrs. King appeared to Betty, who saw her through the kitchen window, where she had died, standing in the garden.

"I went outside and she was gone, but when I came back in and looked out the window, there she was again," Betty told Susan Jimison for the December 26, 1989 issue of the *Weekly World News*. "It happened four or five times, as if she were playing peekaboo with me, until I realized she wasn't real."

At that time, Mrs. King had "been living with us for more than a quarter century," a residency that never bothered Betty. "It's as if my grandmother has come to live with us. She doesn't bother us, but every now and then she gets upset and she rummages around making noise and moving things."

Families expect to be reunited in heaven, but the Williamson family of Dodge County decided to replicate theirs at the cemetery in stone. *Jim Miles.*

However, after living with the ghost for decades, "it doesn't bother us anymore. We're used to it. In fact, if we ever had to move again and she didn't move with us, we'd miss her."

In 1972, the Kights constructed a larger home across Booze Mountain Road from the existing one, and for a short while, they thought they had left the ghost behind. However, within a week, Mrs. King had located them in the new residence and expanded her paranormal repertoire.

Although Robert had never seen the ghost, Betty sighted her on a number of occasions, primarily in the dining room and hall, but only for a second each time. Mrs. King was described as an older woman, clad in an old-fashioned high-collared dress and sporting a bonnet or hat. In decades of sightings, Betty never saw Mrs. King's face. "She's always looking down or away from me," Betty told *Atlanta Journal Constitution* reporter Jack Warner for the Halloween paper in 1992.

On two occasions, Mrs. King communicated with Betty. "I woke up in the middle of the night and heard a voice whispering, 'Your son is sick! Your son is sick!'" Betty reported. "I looked up and there was Mrs. King standing by the bed, she vanished right away."

Robert Jr. was attending Georgia Southern University in Statesboro, so Betty rousted her husband from sleep and insisted that he go check on their son. The father found his son so ill that Robert Sr. drove him straight to the hospital. The young man was suffering from mononucleosis and required two weeks of treatment before he was well.

"Once all the kids were home for a birthday party," Betty said of the second occasion, "We realized we'd forgotten to get the ice cream and the kids said, 'We'll go back to town and get some.' I was standing on the porch and when I heard that, right then I saw Ms. King standing right beside me, shaking her head like this, from side to side. I just panicked....I yelled, 'No, we don't need any ice cream. There's no need for it. Don't go!"

While the children attempted to understand what was going on with their mom, a pickup truck bound for Eastman passed the house. Several hundred yards down the highway, a large truck swerved out of control and crashed into the pickup; both drivers were killed instantly.

"If it hadn't been for Mrs. King that would have been our children," Betty stated. The ghost of Mrs. King might have occasionally been frightening, but she twice saved the Kights' children.

Although Mr. Kight never saw Mrs. King, he did feel her presence. "There's times when I'll be lying on my side in bed at night, watching the TV, and I'll feel the bed move. I'd turn over expecting to see Betty and there's no one there. That scared me real bad the first time it happened."

Robert Jr. also experienced the ghost. While in the seventh grade, Robert recalled, "I was in bed and I heard this eerie noise on the porch. I got up and looked out my window and there in the glider was this little old woman in a bonnet and a little girl. They were holding a little book like a hymnal, and they were singing 'Shall We Gather at the River' in these weird, high-pitched voices. Then they just disappeared. The glider was empty, but it kept on swinging. My spine like to jumped out the back of my neck."

Mrs. King was usually quiet while the Kights entertained guests, but one night, dinner guests refused to accept her existence. "They didn't believe a word of Mrs. King; thought we were just seeing things," Robert said. "Well, I grilled us some steaks, and we sat down at the dinner table inside. We'd just started to eat when this cold wind blew across the table."

"More like a whirlwind," Betty added. "The wind chimes outdoors started ringing and all the smoke alarms in the house went off." The smoke detectors would not stop their wailing until Mr. Kight removed the batteries. "Our guests didn't eat more'n about three bites of their steaks," Robert recalled. "They got up and went home."

After the story of Mrs. King circulated, a lady called Betty one day and described techniques for driving out the ghost. "I said, 'Why would I want to get rid of her? She's part of my family.'"

Despite her attachment to the ghost, Betty hesitated to go downstairs at night to investigate the paranormal activities that emanated from the kitchen. "It's not that I'm afraid something will happen to me," she stated. "I guess I'm afraid I'll learn something I don't want to know. There's some things, you know, that I just don't want to know about."

In 1990, Betty's father passed away, which temporarily seemed to trigger a second ghostly personality in the house. "I was backing out of the driveway to go to work one morning," Robert said, "when I heard a man calling me, saying, 'Hey, hold up! Wait for me!' It was her daddy's voice." That same phenomenon occurred each day at the same time for a week but never recurred. Apparently, the man had moved on to the afterlife.

Their telephone occasionally refused to work, although the phone company found nothing wrong, and loud nightly noises, usually originating in the kitchen, woke them up. Also, after turning in for the night, tobacco smoke was detected. "We come downstairs and right around the bar there's the worst smell of cigarette and cigar smoke you have ever smelled, so bad it burns your nostrils sometimes," Robert said. "But nobody's ever smoked in our house."

Mrs. King "steals my hats, opens and closes our doors, and runs up and down our halls," Betty told Susan Jimison. Mrs. King was ever-present, Betty said. "You know she's here, all the time."

When the Kights brought a Chihuahua, the dog would go crazy each evening at 6:00 p.m., when weird events often occurred. It barked furiously at something near the dining room table and then lunged and seemed to sink its teeth into an invisible being, pulling and tugging backward with all its strength. "That's what made me believe in Mrs. King," Robert said.

As for the reason why the ghost lingered, Betty said, "I believe she feels she didn't finish her mission on earth." Dr. Richard Broughton, a researcher with the Parapsychological Association in Research Park Triangle, North Carolina, said this haunting was typical, "except for the ghost moving with the family."

DOUGHERTY COUNTY

HEADLESS ASSAILANT AND A HAUNTED JAIL

In the winter of 1891, the neighborhood surrounding Albany Baptist Church was "troubled at night by strange and unusual noises," residents reported, according to the *Albany News & Advertiser*, as reprinted in the *Savannah Morning News* on March 15, 1891. The mystery was never explained.

As odd as it sounds, the source might have been a tall but headless phantom that assaulted two men several nights before the press report appeared. According to one of the men, they were walking down the street when their attention was drawn to a tall man standing in the shadow of an oak tree. Following an impulse, they approached the figure while attempting without success to start a conversation with him. The stranger remained both silent and motionless. When the men were within two feet they were shocked to see that the man lacked a head on top of its trunk.

Before they could react, the headless torso raised two long arms and struck both men "with terrifying blows, causing them to fall like sticks at his feet," the article related. One of the victims told the reporter that "he experienced no pain, but a sensation like the tingling of a slight electric shock passed through his frame, and then he became completely paralyzed. He did not lose consciousness, but could not move a muscle nor could he utter the slightest sound."

As the men lay helpless, the figure bent over them and rifled through their pockets. The witness said the headless neck was at very close range and was "forever photographed upon his memory."

The freak apparently did not find what he had hoped for, as "a sign of disappointment came from the orifice of its neck." The creature then laid a hand on each man and administered a second shock, which rendered them unconscious for an hour. Upon reviving, the men found the stranger gone.

In paranormal circles, there is no such thing as coincidence. So, is the headless assailant related to the Albany jail ghost, a phantom born thirty-one years later but only two blocks distant? As everyone knows, we have heard stranger things.

When Dougherty County was created in 1854, the first action proposed was the construction of a courthouse and jail in the new county seat of Albany. The jail, on Washington Street, measured forty by twenty-three feet and was constructed by slaves with brick brought from Macon via wagon.

When a new jail was constructed in 1900, the barred cages and windows were removed from the old jail and installed in the new facility. The prisoner part of the old jail, located in the rear, was now merely a shell, but the front part, which had always been a comfortable apartment for the jailer and his family, was rented out.

By 1922, the Z.T. Pate family had occupied the apartment for several years. They were satisfied with their lodgings until late May 1922, according to a *Savannah Morning News* article published on June 9, 1922.

Late one night, Mr. Pate heard an unfamiliar voice speaking in his home. Concerned, he searched the dwelling. The talking continued, but he could not locate its source. The voice continued its one-way conversation each night and throughout the apartment, but it was most distinct in the kitchen. Repeated searches of the building found no possible explanation.

One night, Pate asked the voice to identify itself. It did not but addressed him by name. On another night, he asked, "What's the matter with you?" The troubling response was, "This rope around my neck hurts." The natural assumption was that the disembodied voice was the spirit of a man who had been hanged in the old jail.

On several occasions, the voice commented on the environment, saying "that he is in a mighty warm place, and he has mentioned the names of persons known locally, who the owner of the voice declares are in the same place."

The story of the old haunted jail spread quickly throughout the city, and although many laughed at Pate, his kitchen was soon crowded each night after supper by the curious. All heard the voice, and none could offer an explanation for it.

The article stated that "not once has the mysterious voice failed to materialize. It will not speak unless there is absolute quiet in the building, nor will it answer the questions of others. But it comments to Mr. Pate on what others say." On several occasions, "persons in the room have spoken in whispers, and instantly, according to the testimony of a number of persons, the voice comments intelligently on what has been inaudible to those a few feet away."

The voice appeared to be that of a black man. One night, two African Americans employed by Pate walked into the kitchen. "Who is that, Mr. Pate," the voice asked. After Pate identified the men, "there was a terrific uproar in the building" that "sounded like a house falling down." No explanation for the audio attack was forthcoming.

EARLY COUNTY

UNCLE JEFF, THE NEWSPAPER SPIRIT

Locating a ghost story from each of 161 localities across the state of Georgia took considerable research and a lengthy period of time. I told Earline I might have to originate a new ghost tradition in one of several problem counties (she swore she would expose me if I did), and Early County was one candidate.

Thankfully, Billy Fleming, publisher of the *Early County News* (serving the people since 1859), came to my aid on August 4, 2010. In his column "Mumbles," he described the supernatural antics of his Uncle Jeff and challenged Early County to provide other local ghostly tales. There were none, but at least we had Uncle Jeff.

Billy grew up in Uncle Jeff's old home, the Fleming House on South Main Street in Blakely. Because Jeff died years before Billy's birth, Billy learned of the ghost from his parents.

Uncle Jeff exhibited the typical ghostly behavior, "occasional knocks, noises and lights," Billy wrote. His mother described the ghost's activity "and hollered at him from time to time."

Jeff's most demonstrative exhibition originated "one night when Daddy was lying in bed with the cover tucked under his arms, reading a paper and watching TV. The covers were slowly pulled from underneath his arms and off the end of the bed."

When the Early County Courthouse was renovated, *Early County News* editor Katie Pando took photographs within the clock tower.

Photos taken inside the clock tower of Early County's Courthouse revealed "a mysterious human-like image." *Earline Miles.*

"One of the photos had a mysterious human-like image in the background," Fleming wrote. "'Probably Uncle Jeff,' I joked."

It wasn't until months later that Billy learned that Uncle Jeff had worked in the building as county probate judge, "explaining what he was doing in the clock tower," he mused.

ECHOLS COUNTY

THE HEADLESS SPIRIT WANTED JUSTICE

For decades, English professor John A. Burrison, who established the Georgia Folklore Archives in 1966, had his students at Georgia State University in Atlanta record folktales from aged citizens of their communities. In 1989, Burrison edited 260 tales, collected by 93 students from 113 "traditional narrators" into *Storytellers, Folktales and Legends from the South*, a book published by the University of Georgia Press in Athens.

In the fall of 1967, student Lynda Carriveau recorded a story, titled "The Grateful Headless Ghost," from her seventy-nine-year-old grandmother in Statenville.

It seems that a rich girl married a poor boy, and her snobbish parents never missed an opportunity to ridicule the lad. After one abusive meeting, the man told his wife that they would take what they could bundle into a couple of handkerchiefs and "travel just as long as we got land to travel on."

As night was falling and foul weather threatened, they stopped by a house to seek shelter for the night. The owner explained that his large family filled his home but said, "That house right down yonder that you just passed is well furnished and everything; stay there just as long as you want to…that is, if you can keep the door shut. That's the reason I left everything just like it is."

The weary couple went to the abandoned house and started a blaze in the fireplace. Before long, strange things started occurring. First a beautiful cat wandered in and then left. Soon a huge cat entered and then exited.

That event was followed by a little dog, which also departed, and finally a big dog made an appearance and walked out. The couple decided that the animals belonged to the farmer down the road, and as the wind picked up and rain began to fall, the man decided to shut the door. As the husband sat down, the door flew open. He again secured the door, but when it slammed open again, he decided to leave it alone.

Directly, a headless man entered the room, and the terrified husband fled the dwelling. His wife, unafraid, challenged the ghost, "What in the name of the Lord are you here fer?"

"Lady," the spirit replied, "you're the first person that's ever spoke to me since I was killed." He assured her, "Don't be afraid. Listen to what I'm tellin' ya now, careful…my brother killed me for my money, but he couldn't find it. I want you to have it. If you'll come an' go with me, I'll show it to ya."

The wife, joined by the husband, followed the specter to an abandoned log cabin. The spirit pulled plugs out of two logs to reveal his treasure, which he gave to her, saying, "Now come and I'll show you my grave, and you do what I tell ya. This money is yours."

In a clearing covered with pine straw and leaves, the ghost said, "Right there is where my brother buried me at. Nobody ain't never found me. They don't know what went wi' me. All I ak a t' do is go git the sheriff tomorrow. You git him an' bring him here time the sun rises good." The ghost wanted the sheriff to bring his brother to the grave site and touch the ground with a finger. "It'll bust a glory o' blood."

When the brother touched the grave, fresh blood oozed from the ground, and he was convicted of murdering his brother. The ghost had bought his justice.

EVANS COUNTY

FOUND A PEANUT

According to a submission on the Ghosts of America website, "Mph" lost an elderly member of his family in 1998, resulting in his first journey to Claxton.

"Everyone was upset and exchanging memories of the deceased, which was beginning to get to me," he wrote. Mph left the interior of the funeral home for refuge in one of the rocking chairs outside. Still rattled several minutes later, he decided to walk beneath some trees on the property and smoke a cigarette to settle his nerves.

"Suddenly, a peanut fell from the sky and it landed near my foot," Mph recorded. "Then another peanut did the same thing. I looked up in the trees expecting to see a squirrel or bird, but there were none. Then about a gallon of peanuts showered down on me out of the clear blue sky. Then I heard some hysterical laughing right in front of me, but there was no one there. I threw my cigarette on the ground and stomped it out and someone blew on the front of my hair to make it move around on my forehead and I could hear some giggling in front of me, but nobody was there."

Odd things often fall from the sky (see *Weird Georgia*, 2000 and 2006), but as Mph noted, "never with laughing or giggling going on while it happened."

Mph told no one of his experience and dreads a return trip to Claxton when another of his older family members die.

GLYNN COUNTY

TRAVELS WITH WANDA

Georgia's Sea Islands have many ghosts, none moreso than St. Simons. The most popular of the numerous ghost stories is that of Mary de Wanda. The popular story has a young man, who argued with his father, angrily rowing his boat to the mainland. Mary, his fiancée, begged him not to go, but he promised to return shortly. A terrible storm, perhaps the hurricane of 1824, swept through, and the lover's boat was found capsized. His body was never recovered. Mary either threw herself into the water to share her fiancé's fate, or returned every night with a lantern to await his return. She wanders still, eternally seeking her man. Occasionally, she is sighted by the living as she trods the island's roads, lantern held aloft.

The best story of Mary de Wanda was related in the fall 1978 issue of *Ebb Tide*, in an article written by Scott Wright and Wendy Stanford.

Carolyn Butler, a thirty-five-year resident of St. Simons Island and a former teacher at St. Simons Island Elementary School, prefaced her story with, "You have to take it for what it's worth because I didn't believe in ghosts and I thought anybody that did believe in a ghost had something wrong with them. But, I guarantee you, if you ever see one you'll know it."

Just before dawn one morning, Butler's little dog, Boots, let her know that he needed to go out. She put on her housecoat and stood at the foot of the driveway while the pet wandered down the street. "All of a sudden she gave out this ungodly, and I mean ungodly, scream. I could hear her just plowing through on up the road. And when she did that, I looked up and right down the road…here was this white thing. And when I saw it I ran.…Boots and

Ghosts are known to walk the historic and scenic sands of Georgia's Golden Isles, including Mary the Wanda on St. Simons Island. *Jim Miles.*

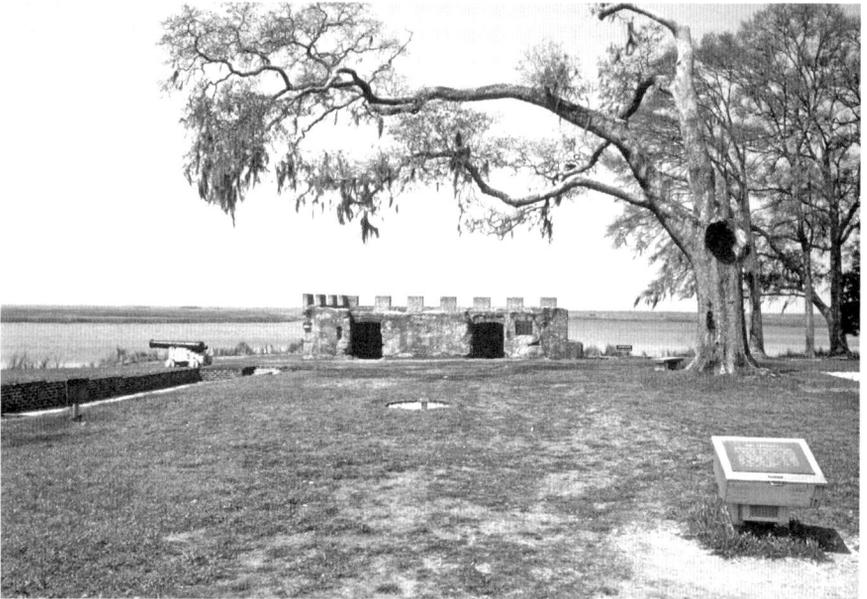

Spirits have been detected at the ruins of Fort Fredericka, a colonial position constructed by Georgia's founder, James Oglethorpe. *Jim Miles.*

I ran to the screen door. I had on a housecoat and she was trying to get through my legs and I was trying to get in the door and when we got in Boots ran under the couch and I ran to the bedroom to tell my husband. I said, 'We've just seen a ghost.'"

Her husband insisted they had mistaken something explainable, but Butler was adamant. She was covered in cold sweat as the dog whimpered from beneath the sofa.

When the dog was allowed out again it ran to a store on Ocean Boulevard, a place Boots had never visited before.

"We went and got her and she jumped in the car with us just like any dog would that loves his master and we brought her home. Boots left. She didn't stay a single night. We kept going to get her, but she never stayed a single night." Eventually, they were forced to give the dog away.

A month or so later, Butler visited an old friend, and over coffee she casually mentioned her encounter. "Oh, my goodness Carolyn," the friend said. "Do you know who you saw…you saw Mary the Wanderer. I've ridden this island night and night and night for years and years seeing if I could see Mary the Wanderer. That's what you saw."

Butler told the story for decades, declaring, "It was only poor Mary."

John Symons and his wife saw the same phenomenon sometime in the 1940s. Late one hot August night, before air conditioning, Symons was home on leave from the navy, and neither he nor his wife could sleep. Around 2:00 a.m., they got out of bed and decided to take a drive in an effort to cool off. They were on the airport road near the Island Club when they encountered Mary.

"I saw a horse with a woman with a veil standing in front of the horse," John said. "She was just standing there and I couldn't believe my eyes. And my wife looked at me and said, 'Did you see anything?' and I said, 'Well, yep, but what did you see?'"

John wanted to know that he was not seeing things. "I saw a woman in white veil by a horse," she said, confirming his own sighting.

Immediately, he said, the car's windshield fogged up so badly that he had to open the door to see. As the apparition continued for five hundred yards, he "had a cold, clammy feeling," and then instantly the fog and the ghost disappeared.

Despite the increasing number of people who seek recreation on St. Simons Island, Mary continues to wander, and sightings continue.

GRADY COUNTY

HA'NTS AT THE HAWTHORNE HOUSE

In the October 24, 1947 edition of the *Atlanta Journal Sunday Magazine*, Wylly Folk St. John wrote of the "Ha'nts at the Hawthorne House," actually two different buildings occupying the same property and located several hundred yards off GA 112, known as the historic Hawthorne Trail, five miles southwest of Cairo.

In 1947, Mrs. Jeanie Welch occupied one of the homes, living with her daughter's family. The elderly woman cautioned that she "don't usually find boogers and don't hunt none," but there were several curious spirits inhabiting her home.

One Wednesday, around 11:30 p.m., Welch was lying in bed with a granddaughter, a lamp burning low because the child feared the darkness, when she heard a sound from a corner of the room, the cry of a baby.

"It made three cries," Welch stated, "like a little newborn baby will, catching its little breath."

Startled, she called for her son-in-law, asking if he had heard anything. Yes, he replied. "It sounded like a baby crying." Welch rose, turned up the lamp and searched first the bedroom and then the entire house but found nothing.

"There was no dog, no cat, no nothin' that could have made that noise," Welch swore. "It was a pure little baby, that's what it was."

Three nights later, about midnight on Saturday, she and her cousin, unable to sleep, got out of bed to sit on the porch, at a window directly opposite the bedroom, "when we heard something in my bedroom that sounded like somebody a-dyin'," she related.

When houses are demolished or rot away, chimneys remain as tombstones to former residences. *Earline Miles*.

Afraid that it was Laura, a family member, they ran inside. In her bedroom, the cousins continued to hear the agonizing sounds, "like somebody strugglin'." Again the family scoured the home for an explanation, but none was apparent.

Welch was left to wonder if a mother had died in that room during childbirth, and perhaps the child also did not survive. She thought that accounted for the haunting of her room but not the rest of the house.

Farmer James Welch and his wife and three children lived in the second structure, which had the reputation of being the hauntedest home in Grady County. Locals, when passing the house, refused to even glance toward it. James Welch did not believe in ghosts but admitted that his home "looks booger-y and sounds booger-y," and his wife, Geraldine, stated that she would not stay in the house alone at night for love or any amount of money.

One hot, late summer evening, when there was not a whisper of breeze, the Welches were inside when they heard the swing on the porch begin moving by itself, so vigorously that they assumed a large person had dropped into it and started swinging aggressively. Alarmed, they stormed outside and witnessed the swing in full motion, but not a person was in sight. It not only swung in the traditional back and forth manner but

sideways as well, a motion it could not have achieved without considerable external force.

Before they moved into the house, the couple had heard numerous stories of the ghost house. "They told me…that sometimes when a man went to feed his mules he'd find 'em already fed, and that I was lucky to get a ha'nt to help me feed." Welch replied that the ghost might feed the mules by itself, but he assured folks that he would not be assisting it with the chore.

Another legend claimed that while you were frying eggs, the spook would grab them from the pan (sounds like the 1964 "Haunted House" song by Jumpin' Gene Simmons).

Although the mules were never supernaturally fed, Welch did admit that "fusses" emanated from the barn.

"It's mostly when you're here by yourself and everything is quiet that you can hear 'em," Welch said.

One night, Welch's brother, Bert, was unable to sleep because of a loud fluttering sound, "like big birds flapping," coming from one corner of his bedroom. Bert got up, lit a lantern and searched fruitlessly.

Author St. John talked to Tom Hill, who had married into the Hawthorne family about a half century earlier. Hill explained that the Hawthornes were a prominent local family and that Bill Hawthorne had constructed the home for his aged folks around 1872. The parents died before occupying the home, and Hawthorne did not want to see other people living in it, so it remained vacant for many years. To prevent kids from raiding an apple orchard on the property, he invented the ghost stories to frighten potential intruders.

"I've stayed there all night, many a night, and I never saw or heard a thing," Hill said.

Over the decades that the house stood empty, numerous young people have visited the house on dares, trying to spend a night in the haunted structure, but rare were those who remained at dawn. Bullet holes appeared in the wall, presumably fired by frightened intruders at imagined or real apparitions. The fireplace was dismantled and numerous holes dug around the grounds by prospectors hoping to find a rumored treasure of fourteen gold-filled fruit jars.

Hill and the Hawthornes might not have believed the ghost stories, but the Welches were certainly conscious of their various "booger-y" activities.

IRWIN COUNTY

THE GHOSTLY SENTRY

When Robert E. Lee abandoned Petersburg and started toward his fate at Appomattox Court House, the Confederate government abandoned Richmond and started south in an attempt to reach the Trans-Mississippi or a foreign sanctuary. President Jefferson Davis traveled through the Carolinas and crossed the Savannah River into Georgia, dissolving the government at Washington on May 5, 1865. Davis, his family and a small cavalry escort camped on the evening of May 9 near the village of Irwinville. During the night, two different units of Federal cavalry found the camp, and at dawn they attacked. The surprised Confederates offered no resistance, but in the early morning darkness, a spirited skirmish broke out between the two Union commands, each believing the other to be Davis's guard. Two Northern soldiers died before the tragic mistake was realized. They were the last casualties of the Civil War, today buried at Andersonville National Cemetery.

The site of Jefferson Davis's capture is now a state park. A museum displays relics, including part of a tree that stood where Davis was seized. A memorial topped by a bronze bust of the Confederate president marks the exact spot of his capture. The site of the skirmish is also preserved.

A posting on a Georgia State Parks & Historic Sites website suggested the little park was haunted, stating, "Some still believe those soldiers haunt the grounds, perhaps trying to find each other for forgiveness. In the middle of the night, one could possibly encounter approaching footsteps despite no living person walking nearby or jump at the sound of mysterious gunfire in the distance. Are these happenings a result of a wayward small animal or the

More than thirteen thousand Union soldiers died at the infamous Andersonville prison camp. Their deaths and misery created intense paranormal activity. *Jim Miles.*

ghost of a lost Union soul? We are left to wonder. Believe what you will!" So, I decided to personally check out the stories.

"Before we moved in here a lot of the locals would come in and tell me, 'This was a haunted place to work,'" said Daniel Gray, then site manager at Jefferson Davis State Park and a native of Cedartown.

"When we first moved into our house in the park," Gray said, "we had pea gravel outside our bedroom window, and I woke up one night. I could hear something walking in that gravel out there. It sounded just like footsteps. I laid there and I didn't move. It was a full moon night and there was enough light so it was bright outside. I thought, I can't wake my wife up 'cause she's

just going to flip out. Our headboard butts up to the outside window and so I lay there and I kept hearing the footsteps and they sounded like he was just pacing back and forth along this gravel outside our house." The footfalls ceased and Gray got back to sleep, but he decided not to tell his wife about the experience.

"Well, several nights later she woke up and heard the footsteps and she didn't tell me either," Gray continued. "One night she and I were watching TV and talking and she said, 'I've got to tell you something. One night I heard footsteps going up and down the gravel outside the house,' and I said, 'Well, I was going to wake you up the other night 'cause I heard the same thing.' I said, 'If you hear it you wake me up and if I hear it I'll wake

While Daniel Gray managed Jefferson Davis Memorial Historic Site, he heard phantom gunshots and a ghostly guard that walked a beat outside his home. *Jim Miles.*

you up.'" He continued: "Three or four nights went by and she said, 'Hey, wake up. I can hear the footsteps.' I listened and I heard them too. We listened for a second and I said, 'Don't move. I'm going to creep up to the window.'" Gray did and peeked through the blinds. He could see the whole area but not a person. "I said, 'Maybe it's just in our minds. We didn't really hear that.'"

Gray added: "It was a couple of weeks after that she woke me up one night and we heard it again. I did the same thing I did before. I looked out that window and I couldn't see anything, and I said, 'Don't move—this time I'm going outside.' So I eased to the front door and I just grabbed the handle and just barely turned it. I had a flashlight and I scooted outside and to this day I have never seen what makes that sound. We always just say there's a ghost outside our window." They had not heard the sentry for some time, but not necessarily because the phenomenon had ceased its activity.

"You are going to laugh at me," Gray said. "I actually took the gravel out because it was annoying us so badly. We poured bark, and that way we would not be able to hear whatever walked out there. I put mulch in the bed just to keep from hearing that so we could sleep at night. This was driving us crazy. I should have been able to see it. I know good and well that we both heard it."

JEFF DAVIS COUNTY

THE RACHEL KNOCKERS

When she was fifteen, Rachel Mullis's mother accepted a teaching position in Hazlehurst, and the family moved into a house there. Rachel took a bedroom in the rear, and on her second day of residence, the room was unaccountably freezing, even when the air conditioner was turned off, forcing her to sleep beneath a heavy blanket. The oddest part was that whenever another person entered the room, the cold disappeared but returned when Rachel was alone again.

One month later, a rhythmic tapping was heard, but only at night. The pattern was *thump*, *thump*, *thump*, followed by a pause, and then the sounds resumed. The taps originated from only two spots, one outside her window and the other from within a closet.

Rachel learned to live with both phenomena. That was the status quo for six weeks until Rachel missed school due to a sinus infection. She was playing a computer game in the quiet house when she heard voices coming from her room, a male and a female, arguing too low to distinguish individual words. Rachel thought she had left the TV in her room turned on and tuned to a soap opera, but the set was off. She turned on music so she couldn't hear any subsequent voices.

Soon Rachel was awakened one night by the knocks, which had moved to the foot of her bed, apparently rapping thrice on iron bars. For a month, she would only sleep there with a light on. The sounds eventually returned to their accustomed locations.

One Saturday, Rachel returned to her room for something and found a cold spot in front of the door. Three days later, traversing the same hall, she discovered that the cold spot had shifted halfway down the hall. At suppertime, she found the spot at the door to her mother's room.

On another night, around midnight, Rachel's mom barged into her room and asked if she had heard something. No, Rachel replied, and her mom asked if she knew where she kept her gun. Somehow Rachel managed to return to sleep after this bizarre episode.

In the morning, the battery in the family car was dead, and the mother called her parents and asked them to bring her father's truck over for her use. As they waited, Rachel asked her mom about the incident the previous evening. Mom had heard a noise, and Rachel asked if it was three taps from outside her window. Bewildered, the mother replied, "Yes, how did you know?"

Not long afterward, Rachel was at the computer when an exceptionally loud thump was heard from a nearby wall, so heavy that she "thought the wall was going to break." It was apparently a farewell signal, for the tapping and cold in her room ended.

These events, which occurred between August 2000 and May 2001, were reported to ghostvillage.com on July 1, 2002.

LANIER COUNTY

WHO BURNED IN THE CHURCH?

Apeculiar story has long circulated throughout this rural county. Storyteller S.E. Schlosser has interpreted the tale well in *Spooky Georgia: Tales of Hauntings, Strange Happenings, and Other Local Lore*.

At an unknown time in the past, a country community was excited to hire a new female teacher, described as "sophisticated, poised, and cultured." Although she seemed almost too good to be true, parents harbored high hopes for the future of their well-educated offspring.

School met in the local community church, where the teacher impressed everyone. Her students loved her and spoke highly of her personality, knowledge and love of teaching. She received glowing remarks from parents who met her.

However, one resident, the town drunk, named Smith, ranted about the new schoolmarm to anyone who would tolerate his company. "That woman ain't natural," was Smith's usual spiel, wrote Schlosser. "I seen her out in the woods after dark, dancing around a campfire and chanting in a strange language." Further, "They say she's got an altar in her room and it ain't an altar to the Almighty."

Considering Smith's character, all rejected his drunken vitriol, but as the school term passed, parents noted disturbing changes in the children. Their youthful joy diminished, and high-spirited play was replaced by troublesome behavior. The children stole money, jewelry and even vital farming implements. They talked back to their parents, lied to them and refused to apologize when caught in dishonest activity.

The pastor's wife was particularly concerned, saying, "The games the children play back in the woods frighten me. They chant in a strange language, and they move in such a strange manner. Almost like a ritual dance."

Residents were loath to admit that the only common source of the concerning behavior was school, and that meant the new teacher. Some began whispering about possession. "That teacher is turning the young'uns to the Devil," declared Smith. "That teacher ought to be burned at the stake, like they burned the witches in Salem."

The minister finally decided to investigate, but he did not act in time. One Monday, his son was kept home from school because of illness. When the preacher returned home for lunch, his distraught wife met him with, "I heard him chanting something over and over again in his bedroom. So I crept to the door to listen. He was saying the Lord's Prayer backwards!"

Before the minister could respond, word arrived that Smith was seen running through town with a torch, screaming about burning the school. Alarmed members of the community raced to the church, only to find the sanctuary blazing. They worked feverishly, beating at the flames with wet sacks and lugging buckets of water from nearby wells and pumps. All could

Stories tell of a Satan-worshipping teacher and the children she murdered in a fire buried in this rural cemetery. *Earline Miles.*

clearly hear the terrified shrieks of the trapped children and their teacher. Smith viewed the havoc he had wrought with joy.

The intensity of the inferno seemed unnatural, and the sounds from the church changed; the teacher was heard laughing hysterically. The inferno blazed for hours, consuming the entire structure. At some point, Smith disappeared, never to return.

Later, the community dug into the ruins to recover the small bodies of the students; the teacher was also found. The children, none of whom could be identified, were buried beneath simple wooden crosses in the adjacent cemetery. The remains of the teacher were buried deeper, beneath a pile of bricks four feet tall.

In recent years, stories have started that people have heard the students chanting in the cemetery, loud but not intelligible. Dark figures have been seen to roam the countryside at night, and full-bodied apparitions—locally called "walkers," some human-like and others animal-shaped—are observed. It is said that bricks removed from the teacher's grave have spontaneously caused fires wherever they have been placed.

"LexABlount," a Georgia college student, was married with two young daughters. Just before school started in 2012, her parents came up from Florida to snatch their granddaughters for a final summer vacation weekend. LexABlount agreed to meet her parents midway for the return handoff, choosing Lakeland, along I-75 near the Florida line. She checked out haunted spots in the area and elected to visit Burnt Church.

LexABlount was dismayed by the absence of cell service on the winding Burnt Church Road. She found the church boarded up and fenced, "hidden behind bushes." The cemetery was old, with considerable vandalism evident.

LexABlount heard voices but dismissed them as unseen local residents, and she captured nothing unusual on photos she snapped. As she shot video with her iPad, she felt someone behind her, but no one was there. Shifting to record random still shots, she wrote, her "iPad is lifted out of my hands for a split second. Literally a split second. Like the weight of it was in my hand and then it wasn't and then it was." She had no idea what had happened "but wasn't scared, just intrigued"; she decided it was time to go.

Several months later, on Halloween 2013, an anonymous woman made a Burnt Church expedition with her boyfriend and a girlfriend, both of whom had been there before. The trio "heard an odd noise coming from a tree near the church," like something swinging from a tree, "but there was nothing among the tree branches." During a previous night's trip, the girlfriend had seen "a black shadowy mass" amid the leaves. She had heard "that they used

Legend has Burnt Church, near Lakeland, destroyed by a demonic teacher who trapped the community's children inside. *Earline Miles.*

to hang people in that tree." The young woman warned that it was only a legend, but what they had heard "was a very strange sound."

The trio ventured deeper into the cemetery, girlfriend in front and then boyfriend and then the anonymous writer, when "all of a sudden our neighbor snaps her head back to my boyfriend, who then whips back to look at me."

"Was that you?" the girlfriend asked the man. The woman had "heard somebody whistle" very close. The boyfriend attributed the sound to a bird, while the anonymous writer had heard nothing. On the way home, the boyfriend admitted he had "heard the whistling and thought that I did it."

The anonymous woman took three pictures with her camera before it warned of low power and shut down, but the following day, she turned the device on and "really freaked" to find it had "100% BATTERY!!!" Four days later, she drove by the cemetery, where she "got a cold chill over my body [and] saw something moving around."

A woman named Kimberly offered a refutation of the supernatural experiences at Burnt Church. Although a resident of Metro Atlanta, she had grown up near the church and repeatedly attended services there, and her grandparents were buried in the cemetery. She had been at Burnt

Church "at ALL times of the night-day-evening…and there are no horror stories" there. She also stated that people who arrive with paranormal phenomenon "already in their perspective mindset" were the ones who believed they had supernatural experiences. Kimberly and other children had played together in the cemetery many times while adults stood around and chatted, sometimes until 1:00 a.m. on weekends, but never "heard of a horror-related story from someone who actually was born [and] raised from Lakeland."

Finally, she declared, "I would still to this day do as I have done many times before—walk in the graveyard at 2–3 am in the morning…BY MYSELF…and think the same as if I was in a Wal-Mart store at 12 pm during the day." Certainly, many residents feel the same way toward local landmarks considered haunted by nonnatives.

I visited the site in January 2017 and found the cemetery peaceful, with no sign of vandalism.

LEE COUNTY

GHOST-ON-GHOST VIOLENCE

A unique story originated from Smithville in Lee County, a community established at a railroad intersection twenty miles north of Albany. First published in the *Smithville Enterprise*, it was reprinted in the October 5, 1886 *Savannah Morning News*.

Around 10:30 p.m. one Thursday night, near a Y intersection of the rails not far from dense woods, a witness clearly heard, "'Murder! Help!' ring out sharp and clean on the clear air," the account read. The male witness said that the panicked voice was definitely a woman's. Being a gentleman, he immediately ran toward the location of the voice.

In 1886, a man in Smithville charged into the woods to stop what sounded like a murder in progress, but the sounds constantly changed location. *Jim Miles.*

"As he neared the wood the cries grew more distinct, until at last he stood face to face with—nothing!" The would-be hero was about to expand his search into the woods, but "his progress was arrested by the sound of scuffling, as of two persons in desperate struggle with each other, directly in front of him. He distinctly heard the clashing of swords in the darkness, and then the sound of a body falling to the ground, the dragging of it away by unseen hands, and then—silence"

The "informant is positive as to having heard the cries of murder and the subsequent noises, and yet he saw nothing." A most curious and unique experience.

LIBERTY COUNTY

CASE OF THE TORMENTED SUITOR

The Caswell House, a two-story structure on the corner of North Main Street and Memorial Drive in Hinesville, was constructed in 1903 by E.C. and Ellen Caswell. Tiring of life on their farm at Canoochee Bluff, located in rural Liberty County on property now occupied by Fort Stewart, they moved to the bright lights of the county seat. In 1951, Ernest and Susie Groover purchased the house and lived there until 1976. Many local residents had visited the house during the years when it served as a doctor's office.

Spooky stories have long been told about the house, particularly whispered voices heard throughout the structure. As one trod the staircase to the second floor, the temperature changed from warm to ice cold. Dogs and cats refused to enter one front upstairs bedroom. On one occasion, a man said that the window drapes in the room attempted to twist around his neck. He managed to free himself and ran from the house.

About ten years ago, a man was visiting with the owner in the comfortable living room. When the host returned from the kitchen with refreshments, the guest said, "I thought you were alone in the house," related Margie Love, a columnist for the *Coastal Courier*, on September 20, 2012.

When the owner assured him that he was, the guest replied, "But I keep hearing whispers in the next room." The two men ventured into the adjacent room and found nothing.

One inhabitant of the house, who is "sensitive" to the supernatural, detected a ghost the first time he entered the dwelling. However, he considered it to be a benign poltergeist that would never hurt a living soul.

A husband killed his wife's lover outside the Caswell House in Hinesville. The lover returned as a whisperer and a face in a window. *Earline Miles.*

Even today, passersby occasionally see a "pale white face" looking out of a second-story bedroom window. The origin of this spirit dates to 1914, when the woman of the house fell in love with a traveling salesman, resulting in an affair. The suspicious husband started monitoring his wife's mail and found the evidence he sought in a letter from the salesman. The husband then falsely told his wife that he was leaving for an out-of-state business trip. The woman immediately wrote to her lover, arranging a rendezvous at her home.

On a cold, rainy evening in October, the salesman arrived in town via the Flemington, Hinesville and Western Railroad. The husband, who had secreted himself across from the depot on Main Street, fired three shots into the back of his rival. The assailant then fled on horseback and was never seen again.

The mortally wounded salesman was carried to his lover's house and taken to a second-floor bedroom, where he died an hour later. The disgraced woman soon left Hinesville and also disappeared.

The ghost of the Caswell House is thought to be the slain lover, eternally waiting for the return of his mistress.

Long County

THE HAIRY MAN OF THE SWAMP

M ike Griffin was born in Ludowici and grew up hunting in the extensive swamps of Long County. "There was only *one* thing I was ever afraid of while hunting in the river swamp—The Hairy Man," he wrote in his blog, "Listen Boys—I Hear the Hounds! Memories of chasing bucks, catching fish, and running from bears," on January 13, 2013.

All of his relatives knew the stories and believed them, and it was a cautionary tale of being alone "in the woods after dark…the Hairy Man would get us." As a child, he loved camping and hunting in the swamp, "but after dark I didn't care much for leaving the light of the fire." Neither did his siblings.

Some considered the Hairy Man to be related to Bigfoot, and although sightings were rare, "he had been seen." Hunters returned to camp and told "about seeing a man-like figure, crouching on a tree limb, covered in Spanish moss, eyes glowing, with a foul smell about him."

As Griffin matured, he forgot about the Hairy Man, until late one afternoon in 1975 in Needmore Swamp, ten miles or more from the highway, where many dirt roads in the area terminated. He was following a good deer path through tupelo trees, confident in bagging a prize. Although dusk was approaching, he refused to abandon the hunt.

Then the sound of a hooting owl came to him from a distance, followed by others, all "making their way down the swamp in my direction." The last hoot, very close, abruptly stopped. That was followed by "a screech, a panicked screech." Griffin was aware that in the past "owls were thought

to be the messengers of death." When his neck hair "stood straight up," he related, "I decided it was time to go."

Returning to his truck meant passing the position of the last owl, but he reluctantly did and continued as quickly as he could without a flashlight in the swamp. "I wasn't scared," he wrote, adding, "I was just in a hurry."

Near the truck, he fell over a cypress knee. "While getting up, I noticed feathers everywhere. Then an awful smell surrounded me. I hadn't thought about the Hairy Man for many years, but all of those stories came flooding back in an instant. I then looked up into the tops of several tupelo trees. They were covered with Spanish moss, but I spotted something. It moved. I moved even faster and quickly got back to the truck."

On the drive down the dirt road, he worried about getting struck and having to exit the swamp on foot at night. A number of years later, Griffin was hunting with his great-uncle, Gene Browning. After he described his encounter, Uncle Gene "said he knew the true story about the Hairy Man."

Near Needmore Swamp, he explained, there was a number of ancient Indian burial mounds, measuring roughly five feet high and twenty feet

One hunter who lost his son in Needmore Swamp searched until his death and then became the Hairy Man, stalking all who tarry after dark. *Earline Miles*.

in diameter. Browning said that the Native Americans who constructed them practiced human sacrifice. When a village elder died, a young child would be killed and buried with the elder to assist with tasks in the next world. For some reason, modern hunters always found bountiful deer around the mounds.

Browning said that when he was a boy, a man was hunting there with his young son. The man directed the boy to sit on a stump and await his return. When the father returned several hours later, "his son was gone, completely vanished." The only living creatures were "several old crows flying about."

The frightened hunter shouted and searched for hours and then drove to Ludowici for assistance. Citizens from across the county arrived and scoured the area by day and night, "with lanterns and blood hounds." No trace of the child was ever found.

Ultimately, the search was called off, but the father never abandoned his mission. Wracked with guilt, he searched the area around the mounds until one day he failed to return home. The man's terrified wife went to the authorities, precipitating another extensive search. One volunteer "caught a glimpse of a man running away from the search party." The father was never seen again.

For years afterward, "hunters would report seeing a ragged-looking man in the River Swamp." Most locals believed it was the father continuing his search. "For many years after the young boy disappeared," Griffin wrote, "hunters would find crudely carved little wooden toys left on the Indian Mounds, as if someone was making gifts for a young boy."

The father would have died years ago, but apparently his spirit continues his eternal search.

LOWNDES COUNTY

GHOST'S CLEAR AT THE BELL HOUSE

D r. David S. Bell came to Valdosta as a small child with his parents and there made his fortune. An activist in local development and politics, he was known as the "Valdosta Town Crier" and Valdosta's "biggest optimist." He died on January 6, 1964, and some sources called it a suicide by hanging in his office. He left a wife and four sisters. Before the funeral, his body lay in state at the house for two days.

Dr. Bell had traveled the south in minstrel shows selling patent medicines, including a tonic labeled "Re-Nue-U." Of that product, Bell advertised that "when you are gone, it will bring you back."

In the mid-1990s, the widow Bell was moved to a nursing home and the house sold. She was one hundred in 1997 and hated the new owners for occupying her residence.

The property at 500 North Ashley Street has been a bed-and-breakfast inn known as the Bell House, a Cajun restaurant called Warren's Blue Bayou and Vito's Pizzeria and Lounge. In every incarnation, owners, employees and customers reported paranormal experiences.

In 1997, the Bell House B&B was managed by Robin Griffin. She received a letter addressed to Bell in the winter of 1997, noting that "the man's been dead for 30 years." Perhaps he still imbibed his own elixir.

Griffin and others had found imprints of people sitting on newly made beds upstairs, particularly in the Peach Room, located in the northeast corner of the inn. On many occasions, "I've come in and there'll be an impression on the comforter," she said.

The Bell House has hosted restaurants, bars and a bed-and-breakfast. All were haunted by Dr. David S. Bell, who hanged himself there. *Earline Miles*.

Three guests saw a ghost and described the apparition, which fit Dr. Bell "to the T," Griffin stated. One cook, Carolyn Mitchell, twice encountered a male ghost, and dishwasher Lori Barton felt "a presence" approach her from behind and drip water onto her back. A deep-fat fryer started up in the dead of night, phantom dogs barked in the darkness, ghostly footfalls were heard on the stairs, lights flickered and security alarms were set off by nothing.

Unexplained noises and other phenomena had previously freaked out employees, and in late January, the kitchen staff made a statement by walking out and forcing the facility to close for a day.

"My help is serious about this," Griffin told the *Valdosta Daily Times* during the ghost strike. "They don't like this, and I'm in a pickle." She found herself reassuring employees that the spirits were not harmful, and when she picked up the phone, callers often shouted, "BOO!" Griffin denied rumors that the facility was closing, quipping, "We're trying to get the ghost to pay his share of the utility bill, but we're not closing."

In response, Griffin and the inn's co-owners, Bunny Carnahan and Billie Jo Fletcher, called for assistance from Georgia's most qualified paranormal investigator, Dr. William Roll, who taught paranormal psychology classes at the University of West Georgia in Carrollton.

Roll was born in 1926 and raised in Denmark. Germany occupied his country in 1940, and after the sudden death of his mother, he joined the resistance movement. During those years, Roll experienced out-of-body phenomena and read extensively on parapsychology. At age twenty-one, he moved to California to study psychology and philosophy at the University of California–Berkeley. After graduation, Roll spent seven years at Oxford University, studying under H.H. Price, an accomplished parapsychologist. In 1957, Roll arrived at Duke University in North Carolina to work with J.B. Rhine, who established the discipline of modern parapsychology. When experiments in ESP went poorly, Roll shifted to psychokinesis, the modern term for poltergeist activity. By 1990, Roll had moved to Carrollton.

Roll, then seventy, brought eleven students and spent the nights of February 27 and 28 at the inn. After their first night's residence, six students reported sighting apparitions or dreaming of such encounters, mostly involving an old man and a dog. Roll thought the man could be Bell.

Carnahan was spooked during Roll's investigation. "It scared the hell out of me," she confessed. She felt a presence pressing down on her, noting that "there was a lot of stuff going on; we lost power six times, and several students reported the smell of cigar smoke."

Unlike modern paranormal investigators, Roll's tools were simple. He reviewed the history of the dwelling, interviewed witnesses to determine whose accounts were genuine and whose were probably influenced by the experiences of others. Roll held a midnight candle-lit psi session upstairs with his students and Carnahan, involving meditation and question-and-answer exercises—what non-scholarly types would consider a séance.

Roll employed only one device, which measured electromagnetic field strength. A normal reading is 2 milligauss. At the Bell House, several locations, including the Peach Room, measured 180 plus. EMF can be generated by electrical machinery as well as natural causes.

Strong fields can affect the mind, inducing auditory and visual hallucinations in the brains of some, while also triggering psychic ability "so that what you see, in fact, occurred in the past," Roll said.

Although the magnetic fields were strong and unusual, "they are quite explainable," the doctor said, so the house was not "haunted in the popular sense of the word," he declared. Haunted houses are "often associated" with strong magnetic fields and "with psychic phenomenon, such as moving of objects and sighting of apparitions." Roll's summary continued: "I feel nothing heavy or harsh, but rather one of protection for the house, wanting the house to continue to be strong and to succeed as a business."

The next house owners were Robert and Kayza Nixon. Their most extraordinary experience occurred to Robert, who spotted a young girl walking through the restaurant. "At first, I thought it might be a customer's child wandering around," he said in the October 2007 issue of *Valdosta Scene* magazine. "So I followed it. It walked through the dining room, around the bar area and disappeared. It was like 2 a.m., and I had to ask someone else if they saw it too. They did."

One morning, after leaving the restaurant the night before with every chair turned upside down on the tables, workers discovered the chairs upright on the floor. One employee left the office for the restroom down the hall and returned to find the office locked.

Customers complained of water dropping on their heads while dining, but no evidence of leaks was ever found. Employees repeatedly watched articles fly off shelves.

Southern Ghost Hunters Paranormal Investigations of Georgia (SGHPIG), based in Tifton, examined Vito's in March 2004, particularly the upstairs, where a woman humming and singing was recorded. As a male voice said, "Why did you shove me?," a drop in temperature was recorded.

A rare phenomenon was also monitored, an apparent two-way conversation between ghosts. A male said, "I love you, too," followed by, "Ummmm, ummmm," and a female called him "Gerald." The woman also said, "Hi." A female ghost was reported in an upstairs DJ booth, according to a report by SGHPIG. On another evening, frightened patrons started "screaming vulgar words toward the ghost…as soon as they were done the lights and sound just cut off for a minute and a cold chill ran through the room. Investigators felt they were being watched on the second floor, and near the DJ booth a cold spot was encountered and an EVP recorded." Everyone reported that the spirits were friendly or at least non-threatening.

The building does not currently host a business.

McIntosh County

BREWSTER PROTECTED HIS HOME AND ITS OCCUPANTS

An old house dating back to the 1790s, when George Washington was president, was constructed on Baisden's Bluff, near Crescent, overlooking Sapelo, Creighton and Blackbeard Islands. The Ridge was a popular spot where planters constructed their summer homes. The house, an early example of Federal-style coastal raised cottage architecture, was one of the oldest structures in the state.

It is thought that the resident spirit belonged to Dr. Francis Augustus Brewster, a medical doctor and minister originally from Hampden, Connecticut, and a descendant of an original settler of the Plymouth Colony. In 1898, he relocated to coastal Georgia to be with his son and his family, who then owned the house. He died at age eighty-nine in 1906 in an upstairs room, since known as Brewster's Bedroom. He loved the house while alive and guarded it until the day it was demolished.

The mansion was last owned by Jack and Debi D'Antignac. Jack's mother, Auvergne, met the ghost around 1940. She said, according to Dan Tarrant in *Ghosts of the Georgia Coast*, "I was sleeping in a downstairs bedroom when I was awakened in the early hours of the morning by a tapping on my shoulder. Sleepily, I looked up into the face of a tall man with blond hair. He said in a low gentle voice that someone was ill in the back room. I had a number of guests that night, and as I was only half-awake, I thought this person to be one of their friends I hadn't noticed. I allowed him to lead me by the hand down the hall into the dining room."

As they walked, the figure passed *through* a big table in the dining room, while she slammed into the furniture. Recovered from her stupor, Auvergne realized that the man she was following was not a guest, as his clothes and high collar were greatly dated. Startled and in pain, she screamed and ran back to her bedroom. She frantically told her awakened husband that she had "met Brewster."

A thorough search of the house produced no extra guest, corporeal or ghostly. Back in her bedroom, Auvergne was horrified to find a deadly black widow spider on her pillow!

The couple believed that Brewster's appearance was designed to save her from a terrible insect bite. If so, this must be an intelligent and thinking spirit, not just a residual ghost going about its accustomed routine. This one was actively shielding the current residents of his former abode.

A similar protective event occurred while Jack and Debi were absent, wintering in Florida. They returned and opened the house the following spring to discover that they had almost lost the house. In one ceiling, the antiquated wiring had shorted out. The dry, heart pine beams of the centuries-old house had caught fire, but the blaze had been extinguished somehow.

"This sort of electrical failure in your house," a fire marshal told the owners, "with such old, tinder-dry beams, would be sure to cause a bad fire. And yet something stopped it before it could spread." "It had to be Brewster," Debi said. "There was no one else in the house."

Jack's father also had a substantial encounter with Brewster. One day, as the elder D'Antignac relaxed on the front porch, visiting with his brother, the two men both noticed a tall man with blond or gray hair, clad in what appeared to be old minister's garb, walking toward them from a nearby marsh. As the figure neared, the men realized that his body ended at the knees. They watched with a mixture of fascination and fear as the apparition ascended the steps to the porch, entered the house and started up the stairs. Apparently, Brewster was headed for his old bedroom, where the sounds of footsteps and noises like furniture being shifted were often heard. The men agreed on what they had witnessed, but neither would tell others the story for some time.

The family often heard knocks, thuds, footsteps, rattling and slamming sounds from upstairs, and these noises were always traced to Brewster's bedroom. That room was kept empty, and some guests had refused to sleep in the room next door to it.

Debi and her sister were alone one night when they heard heavy footsteps overhead. Alarmed, they called a neighbor, who arrived with his shotgun. At

the stairs, he ordered the presence to come down. The footsteps were heard approaching the stairs, and the sounds indicated that it took several steps down but quickly reversed course. A search of the upper floor produced no sign of an intruder. "I have heard noises from up there all my life," Jack told Nancy Roberts for *Georgia Ghosts*, "and I suppose I always will."

Debi had another Brewster sighting. One day, she watched as the ghost, again only partially materialized, passed through a closed and locked door. She also caught moving shadows in the corners of her eyes and sometimes felt sudden, deep chills.

Once Brewster proved fond of a particular candle, but not its location. Debi placed the candle on the downstairs hearth, but Brewster teleported it to an upstairs table. Whenever Debi replaced it on the hearth, she always found it returned upstairs. To conclude the matter, as Debi said, "I guess he just doesn't want it downstairs. And I don't want it upstairs." She gave the candle away.

Unfortunately, this haunted house came to a sudden, ugly end. The D'Antignacs sold the property to a developer who planned to demolish the structure and put up riverside condominiums. Local opposition led the new owner to cancel his development, but then he quietly received a demolition permit from a local building inspector and bulldozed the house overnight on July 9, 2007. The last time I checked, the land was offered for sale at more than $5 million.

MILLER COUNTY

THE RESTLESS DEAD OF PILGRIM'S REST

Two parallel roads near Colquitt are believed to have unusually heavy paranormal traffic. On White's Bridge Road, a female apparition is seen at the bridge across Spring Creek and the cry of a child is heard. At twilight, a man walks east on Mason Road but disappears at close range. The frequent flooding of White Creek has eroded away a portion of the Pilgrim's Rest Church cemetery on White's Bridge Road, and grave markers are found in the stream and strewn along its banks. It is thought that the ghosts of those disturbed souls prowl both roads as they attempt to return to their eternal resting places.

This is the scene of a jilted bride story. A lovely young woman clad in a beautiful wedding gown waited at the church for her fiancé, but he had abandoned her. Heartbroken, she ran to the bridge, climbed the rail and jumped to her death in Spring Creek. Ever since, a ghost light has wandered around the creek and church cemetery as the distraught bride continues searching for her unfaithful lover.

This tale and others are related on "Ghost Story Alley" in nearby Colquitt. The town, known for its semiannual folk play, *Swamp Gravy*, painted stories on a number of downtown buildings. One is that of a man who rode his black stallion past Pilgrim's Rest cemetery one night and saw a woman at the fence in mourning clothes, a black dress and veil. Concerned, he asked, "Lady, can I help you?" She remained silent, so he continued on, respecting her grief.

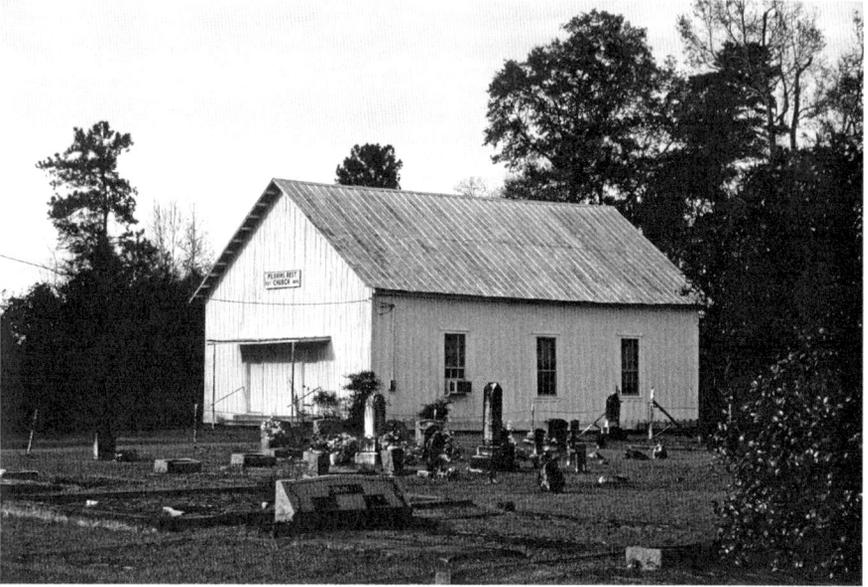

The road past Pilgrim's Rest Church is frequented by a beautiful woman clad in a wedding dress who was jilted at the altar. *Paul Miles.*

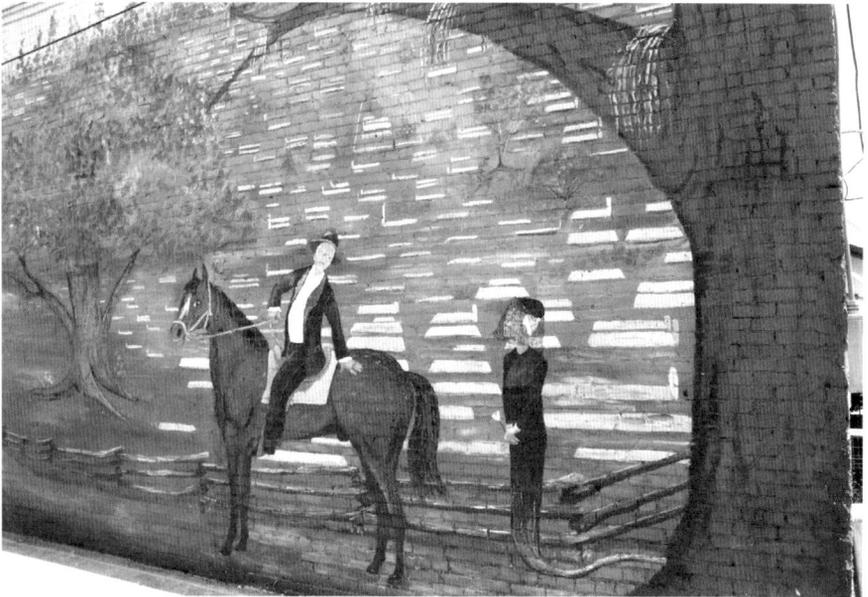

This wall painting in Colquitt depicts a man who learned of his impending death by encountering his spirit wife wearing mourning clothes. *Earline Miles.*

Suddenly, his horse spooked, and the man glanced back to see the woman beside the animal, floating above the ground. She followed him all the way home, where the man told his wife that he would die within a year. Asked why, the man replied, "Because I just saw you in your widow's weeds and you were grieving for me." That premonition came true, we are told.

Colquitt/Miller Arts Council is at Cotton Hall Theater, 164 East Main Street, PO Box 567, Colquitt, Georgia, 39837; (229) 758-5450; http://www.swampgravy.com

Mitchell County

FLORAL GHOSTS

At one point in the past, an elderly couple, the Hilliards, lived in a house and operated a flower business and gift shop in a building behind their home in Camilla. The next owner believed the house was haunted, citing a door handle that constantly fell off, strange sounds and lights that turned themselves on. The Dougherty County Paranormal Investigators (DCPI) asked if the flower shop was also haunted. The owner did not believe it was but gave permission for the team members to search there as well. One team scouted the house while a second group examined the flower shop.

As it turned out, DCPI had made a good call. No evidence of paranormal activity was detected in the house, but considerable phenomena were discovered in the business building. Investigating the shop, ghost hunters used divining or dowsing rods, which are L-shaped copper wires often used to find water, precious metals, graves and spirits. The primary tactic was asking yes or no questions and observing movement of the rods.

The responses revealed that Mr. Hilliard was present and looking for his wife so that they could cross over to be at home with Jesus. Mrs. Hilliard was also still in the building, but each was unaware that the other was still in the home; they are still searching for each other.

The spirit of Mr. Hilliard, found in the back room, was attracted to a participant because she reminded him of a woman he had loved, presumably his wife, and would only communicate with her. The spirited man followed her around the house until she became exhausted, which was when the investigation was terminated.

The rods held by spirit inspectors were often caused by Mr. Hilliard to turn toward this woman and hit her upper arms, as if he did not want her to depart. This activity was captured on video and noted by the investigators, who gave the woman a divining rod for each hand.

The woman did not find the experience of ghost hunting frightening "until the rods kept swinging around and pointing at me," she said. When she took the rods, "they swung back around and began tapping me on the shoulders, as if to embrace me," she told Tom Seegmueller of *Southwest Georgia Living* magazine for the September/October 2009 issue. "I asked if he was lonely, if he wanted to go home. Each time he responded 'yes.' When I asked if he was a Christian, they really came around. I felt like it was real at the time, obviously. But the real emotion was that I felt sorry for him. When I told him I was tired and had to go, they swung back around, embracing me again."

Along for the investigation was a professional photographer and owner of the magazine, who snapped a photograph of a DCPI member while she held the rods. The shot revealed "an orange haze coming from her hands and up to the ceiling," DCPI's report stated. "On her hands, there appears to be another set of hands covering hers."

Most people shown the photograph can make out the face of a woman, whom the investigators assumed was Mrs. Hilliard, in one corner of the picture. However, when the photo was shown to the shop owner and others, most "recognized the woman as a former employee of the florist who had died suddenly."

Montgomery County

THE RAM OF DEAD RIVER

More than eighty years ago, Mrs. Allie Doster of Macon sat down to write an account of a small portion of Montgomery County, which was published on May 21, 1931, in the *Montgomery Monitor* as "Reminiscences Dead River Section" and is available today on familytreemaker.genealogy.com.

In 1720, England's King George ordered the construction of a fort close to the confluence of the Ocmulgee and Oconee Rivers, where the Altamaha originates, which was named for the sovereign. Two and a half centuries later, the Oconee River shifted its course. The resulting oxbow lake, about nine miles south of Mount Vernon, was dubbed Dead River.

On a prominent hill, with a sweeping view of the countryside, early settlers constructed Dead River Church. It was later moved two miles north to Longpond, but the old cemetery remained, and locals continue to bury their kin there, located on County Road 124. Allie Doster considered the area to be all "beauty, peace, and quietness." Two veterans of the Revolutionary War rest there.

Near the site of Fort George, Major Richard Cooper arrived in 1793. Richard's son, George, later received 537 acres of land from his father-in-law, Wilson Connor. When George and Nancy had their tenth child in 1831, they constructed a new home with long, hand-hewn pine timbers measuring sixteen inches wide and six inches thick, held in place by two-inch wooden pegs. Richard helped construct the house and died there. As George and Nancy moved to a larger estate in Screven County, the house was sold to Nancy's brother, Thomas Connor.

The Cooper-Connor House at Brewton Parker College is haunted by the ghost of a Revolutionary War Tory who appears as a ram. *Earline Miles.*

Mrs. Doster recorded that the Cooper-Connor House "has its own special ghost, which comes occasionally in the guise of an old ram!" The animal only attacked descendants of Major Cooper "but has never yet succeeded in injuring" anyone and "is always overcome and dashes off through the woods where he disappears with a mournful bleat!"

The ram is supposed to be the spirit of a Tory, a British loyalist during the Revolution, "who, in life, lived down near Savannah and…was considerably harried by Major Cooper." Cooper and the Tory hated each other, and during an encounter in a Savannah tavern, Cooper shot and killed his enemy. As he lay dying, the Tory informed Cooper that he had not heard the last of him.

After this house was constructed, servants started reporting strange incidents within. Previously locked doors were found wide open, and phantom hoofs were heard tramping across the wooden floors and ascending and descending the stairs. Generations of family members heard the phenomenon.

In 1991, Brewton-Parker College purchased the historic structure, the oldest in the county, and transferred it to the campus in Mount Vernon, where thousands tour it each year.

Jeffery Wells, "the Professor," who has a wonderful website called Georgia Mysteries, updated this story in 2008. During a visit to the house by school students, led by teacher/journalist Kitty Peterson, all heard the front door slam shut, although a check found it still wide open. The party then clearly heard footsteps climbing the stairs toward them, but no one was seen. Students, chaperones and teacher retreated outside and found the ground covered with hoof prints, trampled over the footsteps they had made on their way inside.

Pierce County

I DON'T WANT TO DIE

The stately, two-story home at 417 Church Street in Blackshear was constructed in 1903 by the Taylor family. One evening in 1910, fifteen-year-old Pearle Taylor, a talented violinist, was packing to travel to school and assisting an older sister who had returned home to deliver a child. As she worked upstairs, a kerosene lamp was broken, the oil coating Pearle's nightgown and catching the fabric aflame. Terrified, she ran down the stairs, a motion that caused the flames to burn more fiercely. The child collapsed and died the following day.

The family of Robert and Carol Kodobocz purchased the home in 2004 when they moved from Atlanta. The Sweat family of Blackshear had long lived in the house. As they later spoke to the Kodoboczes, they would casually ask, "Has Pearle been bothering you?"

After moving in, the Kodoboczes heard footsteps ascending and descending the stairs at night. Doors slammed shut and opened on their own, while wine glasses in the kitchen rearranged themselves. The incidents increased in frequency and complexity. "Things sometimes go missing and wind up in strange places," Carol told Wayne Handy of the *Blackshear Times* for the October 24, 2007 issue.

The TV and lights activated and deactivated by themselves, the house would suddenly be filled with the smell of cigarettes and cigars and keys left on a table were found concealed within clothing. "It doesn't happen in the middle of the night, it happens when we're awake," Carol emphasized. "It can play with your mind....You just get used to it, but then there are still some things you don't get used to."

In 1910, Pearle Taylor burned to death in this Blackshear house. Today, she treads the stairs, slams doors and rearranges objects. *Earline Miles.*

Initially, Robert was skeptical regarding the prevalent paranormal activity in his home. Then, one night, as he disparaged the possibility of a ghost, a nearby closet broke out with a pounding noise.

In the spring of 2005, before the high school prom, a son and his friends posed on the staircase for a group photograph. As they left, a bedroom door upstairs was violently slammed, as if Pearle resented being unable to participate in the event. When the picture was examined, a blue orb of light was seen near the group.

The Kodoboczes' daughter, Melanie, who has Down syndrome, pointed a finger at the orb and chillingly said, "That's the ghost that's been bothering me." Melanie had been told nothing of the eerie occurrences. When shown an old photo of the Taylor family, Melanie confidently pointed to the figure of Pearle. Melanie, who occupied the room where the girl caught fire, said that Pearle had asked her to help find something in her closet. Carol noticed that clothing in the closet that Melanie could not reach had been pushed to one side, as if someone had been searching. The ghost only revealed itself to Melanie. "I've never seen it," Carole said, "nor do I want to."

According to Historic Ghost Watch (HGW), the Kodobocz family contacted the organization to request an investigation "to find out once

and for all if the home is, in fact, haunted." Seven team members arrived and conducted a thorough investigation on June 11, 2005, filing an extensive report.

HGW members reported cold chills, feelings of apprehension, restlessness and physical illness. One felt the hair on the back of his neck rise. Investigators heard bells tinkling, doors slamming, popping, ticking, a "shrill," a male whisper and phantom footsteps. The handles on a piece of furniture jangled as if someone was playing with them. A pantry door known to be closed was found open, and a cabinet door opened beside one member. A camera died as a cold chill was experienced, and a camera took a picture by itself. Roses were smelled several times.

The most eerie experience was related by an investigator who felt a touch on the side of the head and heard a voice saying, "I don't want to die." A figure was seen standing in a doorway, and a dark spot was observed as a presence was sensed. One woman felt "that the spirit is or was feeling like she was being torn apart. She said that she felt an intense feeling of apprehension and anxiety."

When the spirit was asked its name, the EVP response was "Pearle." HGW labeled the residence "very paranormally active."

QUITMAN COUNTY

GHOSTS AT MADAME ITURBIDE'S PLACE

In his 1986 book, *Valley Echoes*, *Columbus Enquirer* writer Tom Sellers described a large, crumbling antebellum house located half a mile from Lake Eufaula at Georgetown, all that remained of the "Green place," once the center of a cotton plantation and still shaded by great oaks.

According to an *Enquirer* article from 130 years earlier, a local lady, Miss Green, had married Prince Iturbide, son of Emperor Iturbide of Mexico. The couple had a son before the prince died, and she was unable to gain custody of the child.

Desperate, Mrs. Iturbide traveled to Paris and pleaded for the assistance of Napoleon III. Convinced that the boy would be made heir to the throne of Mexico, she agreed to give up her child. Immediately the emperor "issued an order banishing her from the Empire," the account stated. She returned heartbroken to Georgetown.

A later resident of the house lost a daughter "on the water" in a nautical accident. The mother "believed in the haunted table" during the age of Spiritualism. She thought that a group of people sitting around a table and holding hands could induce the legs of the table to tilt and tap out communications from beyond the grave.

When afflicted with the flu, the mother refused medication, assuring the physician that she wished to "go where her daughter was."

Years later, people observed "blue fireballs" that danced along the banks of the Chattahoochee River near the old Green place. A son of Mrs. Margaret Knighton was hunting with a friend when the blue lights appeared and approached them. The lad fired on the phenomenon three times with his shotgun, but when that had no effect, the youngsters raced for home.

Other residents reported that around the old house, babbling voices were heard and sudden winds arose and swept past them.

RANDOLPH COUNTY

A POST–CIVIL WAR GHOST STORY

An odd story in the *Savannah Morning News* was titled "A MYSTERY OF THE WAR. The Murder of an Officer Followed by a Supernatural Wonder." The tale is similar to one related to the fighting around Atlanta that I described in *Civil War Ghosts of Atlanta*, and like that earlier story, this also involves Federal soldiers.

The war had just ended, and Georgia was occupied by Union garrisons. Federal lieutenant Charles Murphy commanded troops at Cuthbert, while his brother, unnamed, led Federals in Blakely. One day, the Blakely man was ordered to don civilian clothes and walk to Cuthbert, where he would receive the pay for his men. The trip to Cuthbert was soon completed, but the Federal grew weary on the return and stopped at a house for rest, where he unwisely mentioned his mission. After leaving the house, the Union officer was pursued, killed and robbed of the pay.

During the next night, Charles Murphy went to sleep in his tent, but according to the article, he "was awakened by the violent fluttering of the cloth sides." All this on a perfectly clear, calm evening. Charles exited the tent to investigate, only to find the evening quiet, the frenetic tent motion stilled. Perhaps it was his imagination, the lieutenant thought. He reentered his tent, donned his uniform and sat on his cot to think on the phenomenon. In about an hour, he fell asleep again, only to again be "awakened by the noise of the cloth tent as though in the midst of a violent storm."

Leaving the tent a second time, Charles spied the dark figure of a man standing beneath large trees, "beckoning him" to approach. Charles approached the man and discovered that it was his brother, who "told him that he was in trouble a few miles from town and he desired him to return immediately with him to the spot."

Of course, Charles immediately agreed, and the brothers hiked down the road for a distance, turned off to a field and woods to a creek and then down a hill to a swamp, where his brother "suddenly vanished and at the foot of Lieutenant Charles Murphy lay the cold, stiff body of his brother." Horrified, Charles ran back to camp and described the strange incident to the rest of his command. A party of soldiers promptly left camp and returned with the body. Sufficient evidence was discovered for the conviction of a local man, Jim Brown, for the murder.

SEMINOLE COUNTY

THE CASE OF THE CHEATED-ON SUICIDE GHOST

According to Big Bend Ghost Trackers (BBGT), the group was contacted by Scott Lawson of Deep South Ghost Hunters (DSGH) for assistance in a persistent haunting. DSGH had investigated a haunted location, but the affected family "was still having a host of paranormal activity."

The afflicted property was a large modular home that had been purchased from a widow and moved to its current location. The former owner of the structure, referred to as Robert X, had returned home unexpectedly one afternoon and found his wife in bed with another man. The husband left before killing himself nearby.

Predictably, paranormal activity was concentrated in the master bedroom, where Robert X had been betrayed by his wife. The paranormal experiences included the sounds of knocking and the footstep of a phantom, covers being ripped off sleepers, unexplained lights that raced through the room, an apparition that partially formed in front of witnesses and, most frightening, "the feeling of some unseen entity attempting to get into the present occupants' bed." Strange events were "plaguing the family," the report noted.

Investigating members found a heaviness in the atmosphere of the house, "and the sense of being watched was felt by all." A motion detector positioned in an unoccupied room went off sporadically, as did an EMF meter. "A wave of the mysterious lights shooting across the room was witnessed by members of the group as well as unidentifiable smells." A "significant amount of other activity" was recorded on video.

The family requested that the investigators "smudge" the house, which involved kosher salt, yellow sage and salt water applied within and outside the house while a mantra was recited. When the forty-five-minute ceremony was completed, the members felt that the interior of the home seemed "a little less ominous."

When the family was contacted a week later, they reported only one paranormal act; as the team had left, the house shook. Subsequent calls revealed no further problems. BBGT thought the house had definitely been haunted and now was perhaps not.

Stewart County

SOME GUESTS AT THE BEDINGFIELD INN NEVER CHECKED OUT

It is no secret that I am not a fan of modern ghost hunting. I do not believe the reality of any paranormal phenomenon can ever be proven or disproven, and I think investigators should hang around haunted locales to actually witness paranormal activity that registers on our normal human senses.

But never mind. I delighted in an investigation by the Big Bend Ghost Trackers (BBGT), despite the fact that the four-member team arrived with video, digital and film cameras, two audio recorders, four EMF meters, two thermal scanners, a digital thermometer, bionic ears, a dowsing rod and a psychic.

Lumpkin was a bustling, unruly frontier town when Dr. Bryan Bedingfield constructed a rambling structure as his family's residence, his doctor's office and a tavern and inn for weary travelers shifting from Columbus and Americus to Eufaula, Alabama. As the grandest building in the region, the Bedingfield Inn became the center of community and commercial life for some distance.

The noted structure, located across the street from the imposing Lumpkin County Courthouse, was purchased in 1965 by the Stewart County Historical Commission, which has since continued a project to preserve and restore the historic structure to its original appearance. Early "bubbled" glass was secured to replicate every window pane, and ancient brick was obtained for repairs of chimneys and the foundation. Layers of paint were removed from the interior and exterior of the expansive structure to reveal the original colors, which were then duplicated in the restoration.

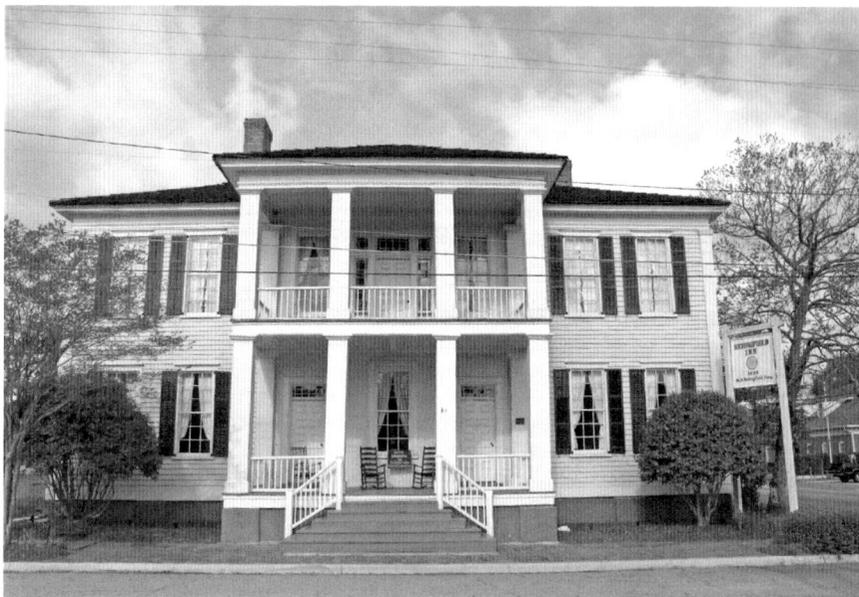

Bedingfield Inn (1836) served southwest Georgia for decades. Paranormal investigators experienced a host of supernatural phenomena there. *Earline Miles.*

At the invitation of local historians, BBGT arrived on the coldest night of the winter. After a grand tour of the structure, the members got down to scientific ghost sleuthing. On the second floor, a scene of considerable reported paranormal activity, two members observed an antique rocking chair begin to rock on its own as the temperature in the room suddenly dropped eleven degrees. In another room, they heard a sound that could not be explained and a smell composed of burning pipe tobacco and old-time medicine. At 1:00 a.m., they retired downstairs, where a fire blazed fiercely in one fireplace for their comfort.

After two hours passed without incident, the team members snuggled down in their sleeping bags, but "more intense and at times more frightful events were in store for us," their online case report stated. After team members were acclimated to the sounds of the old building, "this old inn began to seemingly take on a life of its own," the account continued. "At first it was the footsteps on the hardwood floor above us...then it was the sound in the adjacent room of a dining chair being pulled out from its place at the dining table; shortly thereafter the creaking door to Dr. Bedingfield's office was heard slowly opening."

BBGT members sat up in their sleeping bags and exchanged looks of amazement. "WE HEAR IT…the sound of something being dragged down the long hall above us headed toward the staircase NEAR US! As the sound got to the foyer staircase it abruptly stopped. Then followed…what sounded like marbles to us being rolled down the hallway. This would continue for most of the remainder of the night at various intervals." The report concluded, "As daylight filtered through the antique windows, we all KNEW without a shadow of a doubt we had experienced and witnessed a haunting! Our conclusion: The Bedingfield Inn is indeed HAUNTED!"

The Bedingfield Inn is at Cotton Street on the Square, Lumpkin, Georgia, 31815; (299) 838-6419; http://bedingfieldinn.com; schc@sowega.net. It is open Friday and Saturday, 1:00 p.m. to 5:00 p.m.

SUMTER COUNTY

THE RYLANDER THEATER GHOST

In 1919, entrepreneur Walter Rylander decided that the city of Americus needed a first-class theater for live performances and motion pictures. He accepted a design by New Yorker C.K. Howell, and interior decoration was provided by another New Yorker, William Saling, who favored painted murals, ornate plaster and stencil patterns.

A year and a half later, on January 21, 1921, the facility hosted its first performance. Three weeks later, a movie double feature, Mary Pickford in *The Love Light* and Harold Lloyd's *Get Out and Get Under*, premiered. The Rylander was a center of Americus activity for thirty years before closing in 1951. It had been known as the "Finest Playhouse South of Atlanta."

After a nearly $5 million restoration, the Rylander reopened forty years later as the Jimmy Carter Auditorium at the Rylander Theater, on October 1, 1999, at a birthday celebration for the former president. The regal beauty of the Rylander has been preserved, but comfortable seats and modern equipment have been added.

Although Kent Sole, vice-chairman of the Rylander Authority, said, "We don't know who the ghost is," he believes that a former manager, "a friendly ghost," haunts the theater, remaining primarily in the lobby and the office areas. This spirit has two tricks. One, it locks doors. "You can be in the theater by yourself and turn around and the door's been locked where it had been unlocked," and on some occasions, "when the certain door can only be locked with a key," it locks anyway. Two, the ghost has a personal touch. It can "come up behind you and put his hand on your shoulder," Sole

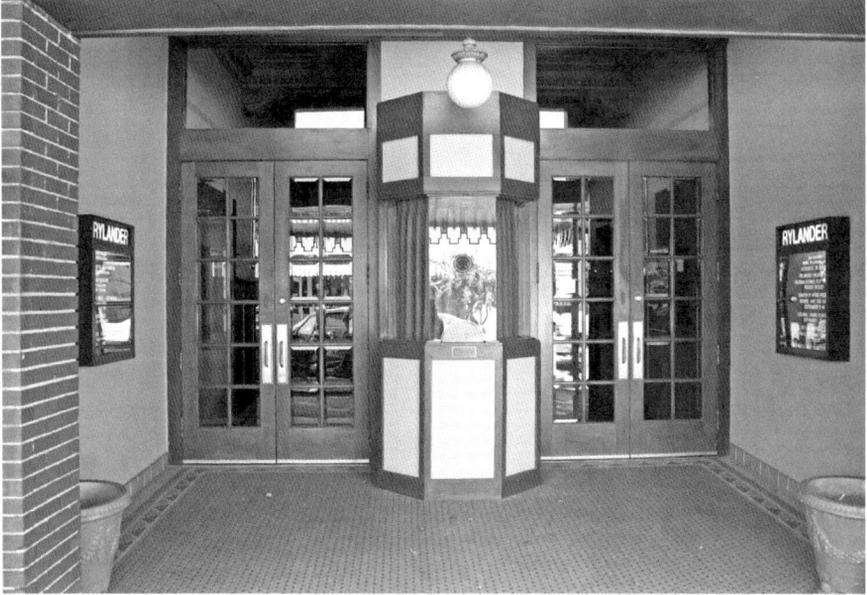

A ghost in the Rylander Theater in Americus locks doors, brushes past the living and taps people on the shoulder. *Jim Miles.*

said. "He likes to make sure the theater is safe—he's always behind you. I was alone in the theater" when the ghost laid a hand on him. Sole whirled around to find no one near him. He searched the building and realized he was alone in the facility. "To turn around, and not know what it is—it's an eerie feeling."

Even before modern ghost hunters arrived, the Rylander was thought to be haunted by the manager who stalked the stairs and projection room and had a mania for securing the property. The Rylander's managing director, Brooks Nettum, also encountered the entity. "Sometimes, I'll go to unlocked doors, and they'll be locked, and I don't think that I have locked them," Nettum said. "I go to work at 6:30 in the morning when it's still dark, and no one else is here. I'll hear something. Every now and then I'll look over my shoulder—I can't put my finger on the feeling, but...it sounds like someone who's trying not to make a sound," she said, referring to a comment novelist John Irving wrote in *A Widow for One Year*. The ghost is a silent presence, but "not an evil feeling." She emphasized that while she had no personal encounters with the supernatural, "I have always been told there were ghosts."

A paranormal investigation team was dispatched from Big Bend Ghost Trackers (BBGT), based in Tallahassee, Florida. The team arrived on

January 6, 2007, and started a six-hour investigation at 8:00 p.m., utilizing electromagnetic monitors, infrared equipment, cameras, tape recorders and thermometers. At about 10:00 p.m., "a loud and distinct crash was heard from within the kitchen area," the BBGT report stated, but an investigation found nothing "out of place." The theater technician "has heard something fall on the floor numerous times but has never found the source," the report noted. Orbs were photographed around the stage, temperature drops of twelve degrees were noted in the kitchen and two investigators felt a "brushing/tugging of their clothes" at the same site, as if an entity had slipped past. Betty Davis, leader of the Trackers, captured an EVP in the kitchen that stated, "I'm over here."

Based on preliminary reports, the Trackers thought the Rylander was haunted by a theater manager. "He probably enjoyed his job so much that he continued to work there in the afterlife. People choose to return to places they enjoyed."

The Rylander Theater hosts numerous events each year, at 310 West Lamar Street, Americus, Georgia, 31709; 931-0001; http://www.rylander.org.

Tattnall County

A HAIRY GHOST STORY

Beards Creek Primitive Baptist Church is one of the oldest churches in southeastern Georgia, having been constituted in 1804. It has its own historical marker, and the adjacent graveyard is extensive and historic as well. Many cemeteries have gained reputations as being haunted, and in recent years, ghost hunters, scientific and otherwise, have frequently investigated these sacred grounds.

One night in 1982, three young friends had heard "rumors of [a] ghost out there," one of the participants wrote online. It was 10:00 p.m. or 11:00 p.m., and the man admitted that each of them had drank a beer, "but we were not drunk. We still had our senses working properly."

A large security light illuminated the church, and as they passed the building, "we noticed this big shadow standing under the light." Wondering why someone was there so late (like themselves), they turned around and pointed their headlights at the shadow, which started running for the cemetery. The boys followed it on a dirt lane through the graveyard. Thinking they had lost the figure, they stopped beside a large grave marker.

Suddenly, their quarry "stood up from behind the headstone. We froze as it stared at us." They froze because the individual "was very tall, about 7 or 8 feet, and had long brown hair that covered its entire body. Its eyes looked red…it only stood there for a few short seconds, and then turned and ran off into the woods. Needless to say after seeing it we did not try to continue to follow it."

Ghost hunters at Beards Creek Primitive Baptist Church were startled when they stumbled across an eight-foot-tall Bigfoot in the cemetery. *Earline Miles.*

Instead of a spirit, perhaps the young men had spied Bigfoot. Our intrepid ghost hunters drove away quickly and never returned. Seventeen years later, one of them reported the encounter to the Bigfoot Field Researchers Organization (BFRO), where it is archived as case no. 2297. A number of other Bigfoot sightings have been made in this rural, wooded and swampy region.

You might wonder how this tale constitutes a ghost story. Some paranormal researchers, myself included, are convinced that myriad supernatural phenomena, including ghosts, Bigfoot and UFOs, originate from the same unknown, and perhaps unknowable, source. A locale might feature a ghost one night, provide Bigfoot the next and offer a UFO after that. Check out the Miles Unified Theory of Weirdness in *Weird Georgia* (2000). It won't change your life, but it might give you a different perspective on the paranormal.

TELFAIR COUNTY

EERIE EVENTS AT GRANDMA'S HOUSE

In September 2005, Rachel L. Mullis related on ghostvillage.com a series of events that had occurred at her grandparents' house in Lumber City in earlier years. It was a fourteen-year-old home with no history of violence or tragedy, but recovered artifacts indicated that the property had been used by ancient Native Americans. Each event occurred when either Rachel or her grandmother or both were present, but Rachel confined her report to three things she personally experienced.

One summer night, Rachel noted an approaching electrical storm. She lit a Coleman lantern and sat on the porch to watch the atmospheric show with her dog. Half an hour later, she doused the lantern and noticed a lighted orb that floated above a line of nine-foot-tall pine trees across a pond. It dipped behind some willow trees as the dog growled, returned to a different part of the pond and then appeared to be approaching the house. "I freaked and ran inside," she admitted.

One day, Rachel's grandfather was hospitalized in Savannah, and her mother left her alone in the house with their three dogs. She was sitting at the dining room table composing a story when a severe thunderstorm passed through. Things were quiet after it blew past, but at that point, a "very loud masculine scream" emanated from her grandparents' room. The dogs immediately alerted and growled. Rachel stood staring at the door and "told whatever had done that to either show itself or go away and leave me in peace." The noise did not recur, but the dogs kept sentinel until Rachel's mother returned.

Rachel visited her grandparents over a long weekend, and late one night, she realized she had no clean sleeping clothes. She took a midnight shower and quietly crept downstairs to start a load of laundry. Several hours later, she returned to the laundry room and found the washer's lid open and the tub filled with water. She closed the lid, which started the spin cycle. Turning around, she saw that a lamp had been turned on. Rachel immediately went upstairs to sleep in her day clothes.

TERRELL COUNTY

A GHOST, A BIGFOOT, UFOs AND A SPECIFIC PIDDLE

Terrell is another county with only one ghost story, and it's a school ghost tale. As a teacher for thirty-one-odd years (some of them *really* odd years), I don't like school ghost stories, for two reasons. I don't want kids afraid to attend school, and the stories are almost always stupid. To wit, in 1977–78, I watched through my classroom window as Peach County High School constructed a wonderful new auditorium. Within a decade, drama students would rush in and breathlessly announce, "The auditorium is haunted!"

"Okay," I responded, "what is the ghost's origin?"

"Well, when they were building the auditorium a worker fell from the roof to his death."

"I was here. Never happened."

"Well, also a student fell from the catwalk during a production and was killed."

"I've been here. Never happened."

"Are you sure?"

"Yeah, that would have been a noteworthy event."

As the dejected students walked away, I always felt like I had kicked a puppy. By now, those stories are so old that I'm certain they have achieved unassailable authenticity.

THE GHOST

Anyway, for the record, according to a three-line entry at Shadowlands' "Haunted Places in Georgia," the girl's locker room at a Dawson school has self-activating toilets, showers and heating system. Further, shadows are seen on the ceiling.

Admittedly, that's not much to go on, but as I stated in the Tattnall County entry, I believe ghosts and other paranormal phenomena have a common origin. Taking that into account, Terrell County has a decent supernatural record.

BIGFOOT

In July 1955, Joseph Whaley was a twenty-two-year-old resident of Dawson employed by the Georgia State Forestry Commission. He was clearing brush that obscured highway signs along GA 118 on Kinchafoonee Creek, several miles northeast of Bronwood.

Hearing a "strange noise" emanating from a thicket, "I walked to the edge of the woods and heard the bushes rattle," Whaley stated. Probing the vegetation, he was alarmed to see a threatening animal walking toward him. The creature "reminded me of a gorilla," Whaley said, in excess of six feet tall and "built something on the order of a man." The animal's body was covered with "shaggy gray hair," described as "like a wire-haired terrier dog," but this was not anyone's pet. The head sported "tusk-like teeth and pointed ears," and it emitted a grunt "like a wild pig." Its arms were "heavy but its hands not very large."

"The creature…walked toward me," Whaley continued. Startled, he defended himself. "I still had my scythe. I took a couple of swings at him and struck him on the arms and the chest. But he kept coming at me."

Whaley was forced to race to his Jeep. Unable to raise a nearby ranger tower on the radio for assistance, he attempted to crank up the vehicle, but the aggressive creature was on him, beating him and tearing at his shirt, leaving three bloody gouges on his left shoulder and arm. Whaley exited out the other side of the Jeep and ran for the woods, his intent to outrun his attacker, which followed with "a lumbering and slow-moving" gait. Whaley doubled back to the vehicle, started the engine and made his getaway.

Shocked by his experience, Whaley immediately found his superior, Forest Ranger Jim Bowen, to relate his bizarre tale, later repeating it under oath.

Bowen went straight to the site of the incident, easily locating "very definitely a trail." He believed "something was there that looked like a large object."

Terrell County sheriff Zeke Matthew and Georgia Bureau of Investigator T.E. Faircloth investigated. Matthew thought there was nothing to the incident, and Faircloth claimed that Whaley had been assaulted by "a hog-bear—a little black bear."

However, the creature near Bronwood was tall, gray colored and looked like a gorilla, not a small black bear.

UFO Blitz

On the night of August 30, 1973, the largest wave of UFO sightings in history broke out in southwest Georgia and spread across the United States. This alien invasion started near midnight when a carload of government workers driving between Bronwood and Dawson on GA 118 spotted two oval-shaped lights moving across the sky. At 12:10 a.m., August 31, these witnesses flagged down a Dawson police car to report "something quite weird in the sky."

Dawson patrolman Gary Ellington, a veteran with experience in military intelligence, also observed the UFOs. His twin anomalies were "sort of shaped like a football about the size of a car," he stated. "They would come in several hundred yards, then back off and fade out."

The unknown craft were "real bright, and the lights were changing colors from white to a reddish orange color to a sort of greenish-yellow color."

Additional Dawson police officers and county deputies scrutinized the UFOs with a telescope. Magnification showed the mysterious craft to be bright in the center and surrounded by a grayish haze. One observer said that when he first saw them, his "knees started shaking."

The UFOs spread out to cover the state, chasing cars, crashing fiery debris to the ground and, in half a dozen incidents, disgorging alien occupants.

The Constricted Rain

On October 10, 1886, the *Savannah Morning News* reported a strange story it obtained from the *Cuthbert Enterprise*. Mr. "Sonk" Phelps reported that for several days, "a distinct rainfall has been noticed, [wetting] a small space of ground in the front yard of a man's dwelling. No clouds were discernible,

and yet to stand in that place would thoroughly saturate a person's clothing in a short time. The ground is very wet, and the water drips constantly from the surrounding shrubbery."

The phenomenon attracted the attention of many people, who visited the site and were "mystified at the remarkable occurrence." During Phelps's visit one Sunday afternoon, he "saw rain falling distinctly…there was a clear sky, and elsewhere was as dry and dusty as a desert." The raining district measured no more than twenty-five feet.

THOMAS COUNTY

MANSION GHOST IN THE CITY OF MANSIONS

The house called Green Square is a modified Greek Revival with elaborate woodwork and plaster molding on the ceilings. Located on North Dawson Street, it was constructed around 1856 by Ephraim Ponder, a wealthy slave trader. He sold it in 1860 and moved to Atlanta, where his wife became embroiled in a sex scandal and he was granted a divorce. He returned to a different Thomas County plantation in 1860 and reportedly died of a broken heart.

In 1869, the trustees of Young's Female College, named for Elijah R. Young, a benefactor who donated $30,000 to the school, used the property as the campus. Green Square served as the president's home and, for a time, as a dorm. The college went bankrupt in 1914, when the house was sold to four men; two would sell their shares to their partners, which formed the start of an odd situation.

Sometime in the 1920s, the house became the property of two elderly women who had long been best friends. Unfortunately, late in life their relationship became embittered. The women came to hate each other so much that they partitioned the house, even building a second staircase to allow each to reach their upstairs section without encountering the other. Every few years, one would paint the exterior of her half, while the other would wait several years to paint her portion, always in a different color. Proof of this odd event is provided by deeds issued on June 26, 1926; one lady owned the northern half of the house and the other the southern half.

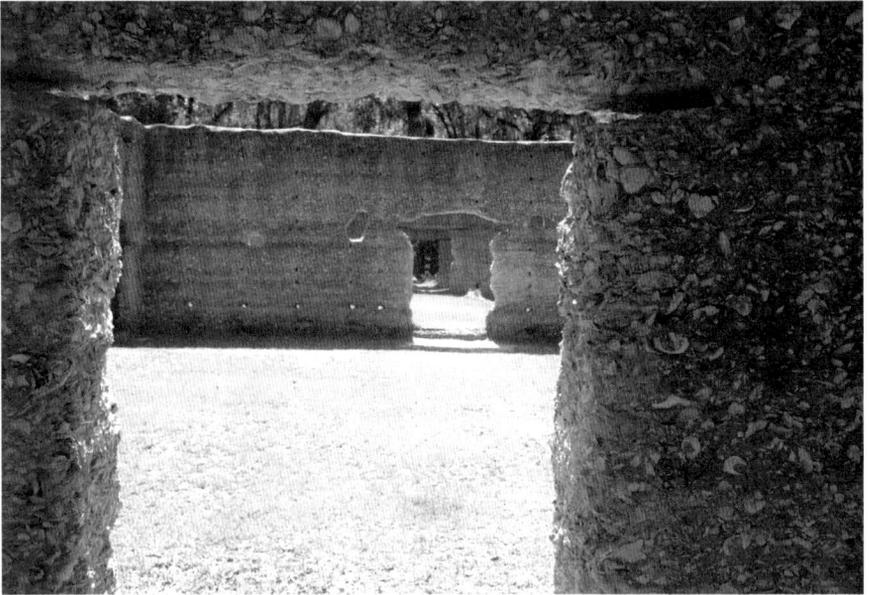

Georgia's first ghosts can be traced to buildings constructed with tabby, composed of sand and oyster shells. *Earline Miles.*

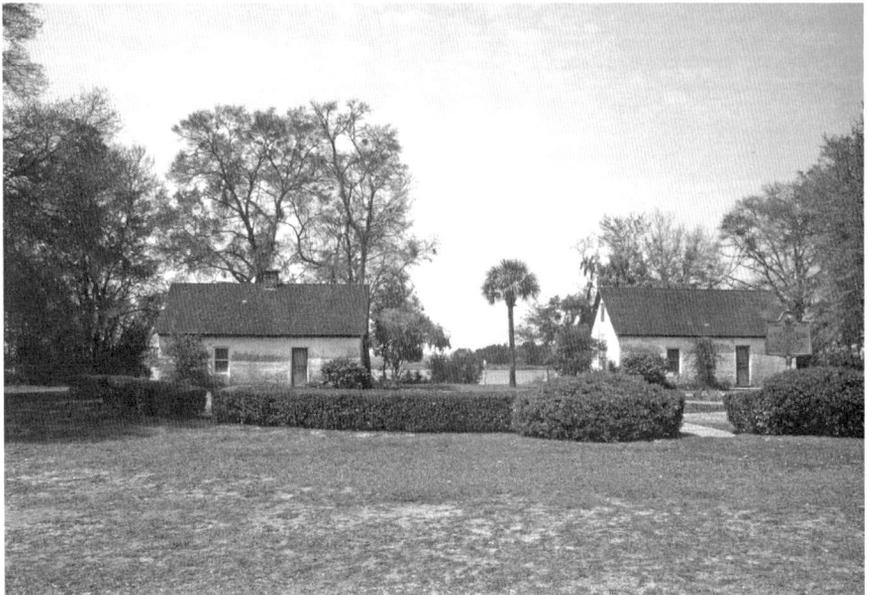

University students recorded paranormal stories from elderly citizens who had once been slaves. These slave cabins are found on the coast. *Jim Miles.*

Jean Parker, a former owner, said that one ghost paid a regular visit once a month, always between 10:00 p.m. and 10:30 p.m. The front door would be heard to open, and then footsteps in the front part of the house were detected before the door was heard to close. Only once did the phantom visit during daylight.

Parker never saw the ghost, she told Dan Trout of the *Thomasville Courier* for the October 7, 1976 edition, but she believed her dog could; it became extremely agitated during each visitation. On occasion, the spirit would be heard to whistle or grunt.

Tift County

THE KNOCK-KNOCK JOKESTER GHOST

In early 1983, Jana Lane, a writer, moved into a house in Tifton that had belonged to her family for some time. She and her teenage son, Wes, renovated the structure and acquired a Sheltie dog named Beau. One evening, around 8:00 p.m. several months later, Jana took a bath while Wes, who played in his high school band, practiced the saxophone in his bedroom. Suddenly, Beau started racing from Wes to a side door that led to a garage, where he would bark furiously. Wes followed the dog and waited patiently at the door, perplexed. The garage door was locked at dark every day, and no one could be outside that particular door. Then he heard *knock, knock, knock* from the door.

Startled, Wes queried, "Who's there?" There was no answer then, nor one when he repeated the question. Shaken, Wes returned to his room and loaded his shotgun before returning to the door, where Beau stood guard. When the knock repeated, Wes opened the door and found what he had hoped for: nothing. The young man returned to his sax.

The cycle started again, with Beau running back and forth. Shotgun in hand, Wes returned to the door, waited for the knocks and quickly opened the door—again nothing. Wes took station outside his mother's bathroom door as the dog continued his circuit. Jana was startled to find her son waiting for her, shotgun in hand. She did not frighten easily and assured her son that there was no danger. She went to her office, adjacent to the garage, and worked on a manuscript. Suddenly she heard the knocks, this time on a back door off the kitchen. She walked to the door, met there by Wes and

Beau, who had also heard the sounds. Several minutes later, the knocks were repeated, but faintly, like tapping. The top half of the door was glass covered by a curtain, and a light burned on the step outside. Any visitor would have been clearly visible, but no one was seen and their inquiries went answered.

For two hours, the knocking continued at different exterior doors, and Wes patrolled the house with his weapon at the ready. Finally, Jana called police and reported a prowler. Officers searched the yard and neighborhood but found no one. Throughout the night, they regularly patrolled the street, probing with a searchlight, but nothing was detected. Over the coming months, the police were frequently summoned, responding faithfully but never finding anything wrong. Jana stopped calling them, fearing they would conclude that she "was a little on the daft side."

Late one night in 1982, Jana and Wes were deeply asleep when they were awakened by "a terrible noise and shaking" as "something hit the side of the house" at the head of her bed. Wall and bed shook, "accompanied by a thunderous sound." Mom and son searched the property by daylight and found nothing amiss. Neighbors had not heard a sound.

On a different evening, Wes was away and Jana enjoyed "a quiet relaxing, uneventful evening." She fell asleep and was startled "by a very loud crashing sound in the dining room." Investigating, she discovered that a mirror had fallen from a wall and shattered. The frightening thing was that the shards were not scattered across the floor but rather were "in a very neat pile. Like someone had swept it up." Terrified, Jana left the house in her pajamas and drove to her sister's home.

It was early in 1989 when a friend pointed out that every living thing in the house, save Wes and her, had died. Each plant and pet had died, including faithful Beau. Frightened by that implication, Jana turned to a friend, a former priest, who gave her a blessed silver crucifix and detailed instructions on how to banish the phenomenon from her home. For a year, no paranormal events occurred, at least by the time her account appeared in the *Tifton Gazette* on October 31, 1985.

TOOMBS COUNTY

WHERE GHOSTS AND ONIONS BLOOM

Castleofspirits.com listed the experiences of a man who described himself as an "Urban Archaeologist." By the way, according to UA, his art leads him to "infiltrate buildings that are about to be torn down, abandoned, or otherwise inaccessible." His experiences formed the title of his posting, "Sometimes…You Wonder."

In 1999, UA moved to Vidalia and took a job in a local department store. His paranormal experiences "started with the small things," he noted. He would glimpse a child run past the office door, and phantoms tapped on that same door. After he had opened all the doors to the dressing rooms, each would suddenly close. One night, he heard "the sound of boxes being thrown around in the shoe department. The sound was horrible, sounding like a person was standing there throwing everything they could find from the shelves. I even went so far as to call my manager. He heard the sounds over the phone and rushed over." A thorough search revealed no intruder and no disturbance in the shoe department or anywhere else.

In 2005, UA found his talents employed by a man who owned several old buildings in Vidalia that had been sealed up for some time. His job was to note historical points of each building; the report would be used as a guide in renovation.

Entering the third floor of one building, he detected a burnt smell and observed evidence of a fire. The scent "seemed to follow me," he noted. Opening the last room, he was "presented with a nice gentleman in a button

down shirt sitting in an office chair. He had this look on his face, like he was waiting on someone."

Thinking that the man was connected with the owner he was working for, UA apologized for intruding and left. Later, he saw a photograph from the 1940s that depicted the man. Clipped to the photo was an article about a murder/arson case. The man, a controversial news correspondent, had been slain and the fire set to cover the crime. The killer was never located.

In 2006, UA left a coffee shop downtown and started wandering the streets, examining the architecture. Beside the old theater, which was being renovated, he turned down an alley. As he walked, "I found myself listening to the footsteps. Which was odd,

People walking down a certain alley in Vidalia hear footsteps pacing behind them, where a man was killed by a falling brick. *Earline Miles.*

since I was wearing sneakers. The footsteps were right behind me, sounding like someone in leather soled shoes, pacing my every move."

When UA stopped, the footfalls also ceased. Turning around, he found no one there and continued on his way. It was then that he "distinctly heard a person turning round and walking out of the alley." UA later learned that in the past, a man using the alley as a shortcut was killed by a brick that fell from the theater. Since then, people walking down the alley find his spirit following them, "only to turn and walk away after they pass the spot he died."

Turner County

THE OLD HAUNTED JAIL

The Turner County Jail was constructed for $10,000 in 1907, just two years after the county was created. The Romanesque structure, dubbed by inmates "Castle Turner," was so striking and the grounds so well kept that it was sometimes mistaken for a nice hotel. The jail was used until January 1994, when a new facility was opened.

The first floor of the jail resembles a nice residence; for decades, the sheriff and his family lived in these quarters, where the wife cooked meals for the prisoners. On the second floor, the walls and floors are either solid plate steel or steel lattice, and the windows are barred. The four regular cells are seven feet square, each capable of holding four inmates, who slept on a pair of two-tiered bunks. Each pair of cells shared a toilet. Two cells were set aside for women. The hanging room, hanging hook and trapdoor remain. The trapdoor was welded shut in the 1930s after the state outlawed hanging in favor of electrocution.

Two men were executed in this facility. For murdering a man during a robbery, Robert Henderson was put to death on May 23, 1907. After shooting a relative to death, Miles Cribb was executed on September 14, 1914. One of the jail exhibits is a piece of a bloody shirt Cribb wore at his execution.

In late January 2009, the Dougherty County Paranormal Investigators (DCPI) brought a team to the jail, starting its routine at 5:30 p.m. Armed with standard equipment, the members set up in rooms and cells and monitored the building for paranormal activity. The exercise concluded at ten o'clock, when all retired to the Waffle House to decompress and compare notes.

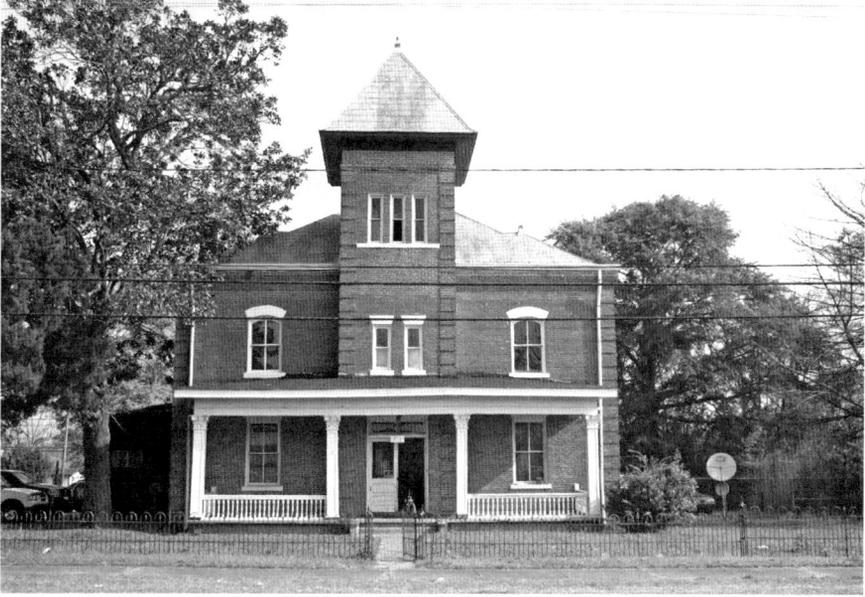

Spirit seekers in the old Turner County Jail were scratched and heard doors slam, and one felt possessed by a long-dead prisoner. *Earline Miles.*

The team was accompanied by Ben Baker, editor of the local weekly, the *Wiregrass Farmer*, and a member of the county historical society. "A couple of them thought some items had been moved around in a couple of rooms," Baker wrote. "A couple more who said they were clairvoyant said they sensed a red-haired woman in the downstairs sitting room, but that she seemed happy and didn't appear to view the room the way we do. I told them all the furniture here isn't original to the building. It was donated after we set up the museum. They said that may mean she's a 'residual' associated with one of those objects, not the jail."

One man was shoved in the back when no one was near, and another felt a scratch on his back, like from a stick or nail. "We looked, and there was a welt on his back. But no one was with him when he said he felt he was scratched." Tour guide Marti Warren has never experienced anything unusual, a view she strongly endorsed when I toured the museum in the summer of 2009.

The reporter at the museum investigation was naturally skeptical, but a review of the investigation report filed by the DCPI gives a different dimension to the experience.

Using a dowsing rod, the investigators contacted the spirit of a convict who had been hanged in the jail. One member sensed the presence of a "red haired cleaning lady." The indention of someone sitting on a foam pad mattress was photographed. The shirt of Kyle, the member who was scratched, was unmarked, and it was determined later that a few minutes earlier and on a different level, a team member had mischievously requested that a spirit "do something to Lyle." That paranormal event seems to have been provoked.

Other physical manifestations of ghosts included hair being gently pulled and an ear tugged. Odd smells—including wet dog, cigar smoke and cleaning supplies—were detected by several investigators at different times. What sounded like a chain being dropped on a metal floor was heard as an EVP uttered, "Let's pick the lock."

During the investigation, a digital recorder that kept turning itself off was found to be "locked up and unusable" afterward. None of its files could be recovered. Apparently, something didn't want to be recorded.

An earlier investigation had been conducted on October 6, 2007, by Big Bend Ghost Trackers between 8:00 p.m. and 1:00 a.m. The five-member team, accompanied by six others, was equipped with the usual array of ghost-seeking items.

Men were executed in county jails, while others died of abuse or suicide. Many of these facilities have ghosts. *Earline Miles.*

During the night, the sound of a cell door near the hanging room was heard to slam shut. The mattresses in the cells had been previously inspected, and afterward, they found the impression of a person sitting on one of them. A black mass was photographed in the cells, an area that also produced strong EMF fluctuations.

Investigator Lisa, while mediating, "had the feeling of a possible possession. I felt that the left side of my body wasn't mine. I felt as though I was channeling the spirit of an African-American person. I felt my facial features changing. That scared the hell out of me so I jumped up and started to mingle with everybody else."

On April 13, 2013, two investigators with the Ghosts of Georgia Paranormal Investigations (GOGPI), Gretchen Mann and Ed Laughlin, and two guests, Ben Baker and his daughter, Susan, arrived at the Old Jail Museum with the standard gear: two digital cameras, four IR video cameras with a DVR, five EMF meters, three audio recorders, two thermometers and one Spirit Box.

Gretchen heard conversation, a female voice, footsteps and movement/motion. Three times she felt she was not alone in the basement. She detected the presence of a woman and "saw what appeared to be a little boy look into the room." EVPs included breathing, a metallic bang and other metallic noises and the words "Shank," "Mike," "Yeah," "Look/Shut Up," "Right," "Eric," "Up" and "Yes" (twice).

A second effort occurred on March 15, 2014, with Gretchen, Ed, Christie Bradley, Chris Bradley and Larry Conley, as well as the usual hardware plus an Ovilus and a thermal camera. In the basement, Ed heard noises from above, like "someone moving around and sliding something on the floor," and "disembodied voices." Larry heard a whistle and Chris a childish giggle. Gretchen heard two whistles, and in the basement, she felt "unnerved." She smelled cigarette smoke and in her head received the name "Shaggy." Zoinks!

Considering their findings and the stories from so many people who have had experiences in the jail, the investigators concluded that the building "has paranormal activity and is haunted." There is nothing negative, and it is believed "spirits from the past [are] willing to communicate with the living."

The Crime & Punishment Museum is at 241 East College Avenue, Ashburn, Georgia, 31714; (800) 471-9696; www.jailmuseum.com. It is open Tuesday through Friday, 11:00 a.m. to 5:00 p.m.; admission is charged.

Note: Spirit Boxes and an Ovilus are somewhat similar paranormal research devices that allegedly allow communication with the dead. Ghosts are generally believed to have the ability to manipulate electromagnetic energy. Spirit Boxes use radio frequencies/white noise to allow "messages" to be received from the "other side." An Ovilus is a device that reads temperature and electromagnetic fields to produce words, chosen from a database. Both devices are of dubious scientific use.

WARE COUNTY

GHOST LIGHTS IN THE SWAMPLAND

A RIDE AMONG GHOSTS" declared a headline in the *Savannah Morning News* of January 5, 1893, describing an incident that had occurred just a few nights earlier. A gentleman of good character was driving his horse and buggy on a road that crossed the Satilla River. He had just approached the covered portion of the bridge when "a bright light filled the space," the press account stated. The cold, rainy, dark night was illuminated to such intensity that his horse shied and refused to continue. The rider dismounted and led his reluctant animal across the span. The light remained at the bridge until the man entered a swamp and his view of the remarkable sight was blocked. Unfortunately, this is when the terrifying part of his strange trip started.

At the center of the swamp, where the darkness was nearly total, invisible hands began to touch his back and shoulders. He looked all around for his tormentor, but no one was present. The phantom hands continued to explore different parts of his anatomy. When the entity laid a hand on some part of his body, the man would shift one of his hands to that location, "but immediately the ghostly hand would rest on another part of his body." The phenomenon ceased as he emerged from the swamp. At home, he barely had energy enough to put the horse and buggy away and enter his dwelling. He thought that another half mile of swamp would have rendered him unconscious.

Those who heard his story suggested that the light was the result of swamp gas and the hands the result of his isolation in dark swampland. The witness

Swamps are foreboding places where spirits of Native Americans, settlers and slaves materialize. *Paul Miles*.

swore to his experiences "and did not care to discuss the subject any further," the report stated.

On December 12, 1897, the *Savannah Morning News* reported a railroad mystery light sighted by engineer Alvin Johnson as his locomotive approached the Kettle Creek trestle, located three miles from Waycross on the Waycross Air Line. The illumination, described as being the size of a standard light mounted on a locomotive, was "swinging across the track at the center of the trestle....Johnson and his fireman, fearing it was a sign warning of danger at the creek crossing, immediately reversed the engine, and as soon as the train shuttered to a halt, the light disappeared. In the past the ghost light had been seen at the same location by locals, but no one could venture a reason for its appearances."

WAYNE COUNTY

POLTERGEISTS AT DALE

Thirty years ago, George M. Eberhart compiled the massive reference work *A Geo-Bibliography of Anomalies*, a huge volume listing the sources of thousands of mysterious phenomena that have occurred across North America. I recently tracked down a reference to a mysterious event that occurred at Dale. Although I am familiar with most of the communities in Georgia, even the smallest burg, I drew a blank with Dale. So I whipped out another outstanding reference work, Kenneth K. Krakow's *Georgia Place Names*. I experienced an "aha!" moment when I saw that Dale was actually Dale's Mill, a now vanished railroad community established in 1881 and named for the owner of a sawmill and postmaster. It was located in Wayne County, just north of the present site of Screven, and is the current location of a prominent ghost light (see *Weird Georgia*, 2000).

In the *Occult Review* of May 1911, T. Hart Raines, a medical doctor, described an event that had occurred in January of that year. Along the tracks of the Atlantic Coast Railroad, there was a multi-story telegraph house, a simple one room above one room, with a trapdoor on the second floor lending access to a staircase. There were no other structures within a quarter mile. This building was unattended for nine months of the year, but it opened January through April for the seasonal "snowbird" migration of folks from the frozen North escaping to Florida.

On January 4, 1911, three young telegraphers—Bright, Davies and Clark—opened the house, where they lived and worked; one of them was always on duty. The men had hardly settled in when the closed trapdoor

began flinging itself open suddenly and with some violence. The men attempted to secure the door with large nails and an iron bar, but it was still thrown open. When the three men were all upstairs and no one else was present in the house, they heard loud footsteps treading the stairs. Thorough searches revealed no human visitor. Soon the phenomenon started raising and lowering the windows in the second floor, these acts being witnessed by all three men, none of whom was near a window.

Soon, Dr. Raines's report stated:

> [V]arious articles began to be levitated about the room in broad open daylight in full view of all three occupants of the tower, when there was no possible chance for trickery or fraud. A can of condensed milk was seen to lift itself into the air and pass from one end of the desk to the other without the contact of a visible hand. A large dish-pan lying near the stove slowly lifted itself and rolled down the stairs and out of the tower and under it, from whence it had to be fished out with the aid of a long pole. A lantern was levitated on to the desk without having been touched, and in full view of all. On another occasion this lantern made a wild rush across the room and dashed itself into fragments against the wall. An ordinary can opener flew wildly about the room and fastened itself in the centre of the ceiling… Frequently bolts and taps, such as are used in railroad construction work, would be hurled into the room, breaking a hole in the glass of the window scarcely large enough to enter through.
>
> On one occasion, when objects were being hurtled about the room so persistently that the tower was hastily abandoned by all three occupants, a chair was dashed out of the upper window and fell with such force that one of the rings was broken. This in broad daylight, with no one in the tower, and the only avenue of entrance or of escape guarded by the three occupants of the tower.

One telegrapher was so frightened that he walked seven miles to town in order to submit his resignation, assuring the doctor that "nothing would induce him again to go through the eerie experience he had suffered."

Dr. Raines traveled immediately to Dale and closely interviewed all three witnesses. He found the workers to be intelligent and truthful, "not deceived nor hallucinated, and they have all signed a statement certifying to the truth of the facts." When Raines examined the chair, he concluded that "only a terrible blow could have so injured it."

This impressive story becomes astonishing when its proximity to Surrency in Appling County is realized. In 1872, just twenty miles distant, one of the most impressive and highly documented poltergeist acts in human history occurred, which I have described in detail (*Weird Georgia*, 2000). Did the ghost of Surrency migrate to Dale thirty years later? It would seem to be too much for mere coincidence to explain.

WEBSTER COUNTY

PROFANE FARMHOUSE GHOST

A family once occupied an old farmhouse located between Preston and Plains, presumably along U.S. 280/GA 27. Their residence was less than idyllic. Members often heard heavy footfalls from an upstairs hallway and bedroom. One resident watched as a black mass appeared, and all believed that they were under observation. Lights flickered and sporadically appliances activated and deactivated themselves.

Supernatural occurrences became so intense that the family suddenly decided to vacate, leaving everything behind, including furniture and personal effects. Over the years, they occasionally returned to retrieve property but always became so disturbed that they retreated from the house within minutes.

The house lay abandoned for years until the family requested a paranormal investigation by Bi-City Paranormal Research (BCPR) of Columbus–Phenix City, Alabama. Several family members decided to accompany the ghost hunters on their expedition one October evening. "The entity in the house seemed to have an attachment to the youngest daughter and she bravely participated in our investigation," stated the report on the BCPR website.

The electricity had long been turned off, so the investigation was conducted via flashlight and oil lamps, which had to magnify the creep factor. The organization stated that activity was scarce early in the evening, but as the hours passed, "we seem to establish communication with the unknown entity."

Some houses are so haunted that families refuse to stay long. Eventually, no one will live there. *Earline Miles*.

Footsteps were heard upstairs when no one was there, and EVPs included, "If I leave," "Are you jealous?" "Out of mind" and an unprecedented "Fuck you," demonstrating a spirit with real attitude. There was an audio reply from a Spirit Box question, and flashes on a K-2 EMF meter appeared to answer several enquires. Photographs captured faint figures in a window of the house and something running by a window.

It seems unlikely that anyone would ever inhabit the structure again.

WHEELER COUNTY

THE ANCESTRAL HAUNTED HOUSE

Wheeler County was one of the most difficult counties for me to find a ghost. For a while, I feared I would have to retell a story about an image of Jesus that was projected on the side of a rural home I included in *Weird Georgia* (2000), but I would have titled it something like "Appearance of the Holy Ghost?"—that struck me as being disrespectful, and I have enough belief to not risk divine wrath.

During my last, lengthy search for a Wheeler County ghost, I found a forum on Woody's Outdoor Taxidermy Talk, part of the Georgia Outdoors News Forum website, where Javery from Ellijay mentioned his haunted ancestral home in Wheeler, which proves that you can find ghost stories anywhere. I requested an interview, and the following day, John Javery called and told me his family ghost story.

John, his wife, Babatha, and their twin daughters live up north in Gilmer County, which was Babatha's home. When John was discharged from the army, they decided to settle there, where he is a welder with a passion for hunting and fishing.

John's roots are in Wheeler County, where the family home place was built in 1919 by his great-grandfather. John's grandparents moved in after he died. "Some strange things have happened there," he related. His grandmother told him that "she'd seen things from time to time. There is a real long hallway in that house, and a lot of times they would wake up at night and would swear it sounded like a woman, wearing those high heeled boots like they used to wear, walking up and down the halls. A lot of people died in that house over the years, and they always used to have the family wakes there."

After John's grandfather died, a cousin, Perry Avery, was sleeping in that same room, which had separate beds for his grandparents. "Perry was sleeping in my grandfather's bed and he woke up during the night and my grandfather and an uncle who had died were standing over his grandmother, just looking at her. He said he wasn't scared. He was almost comforted by them being there."

In the morning, Perry's grandmother cooked breakfast as he got ready for school. He was anxious to describe his experience to her but didn't know how to broach the subject. "He just went ahead and told her exactly what he had seen while she was eating. She looked at him and just dropped her fork, she was so shocked. She said, 'I saw the same thing.'"

John's personal experience occurred just after he was married in the mid-1990s. "I woke up and it felt like a gorilla was sitting on my chest. I swear someone was holding both of my shoulders, holding me down in that bed. A number of people had died in that bed." He thought the encounter "was just the strangest thing."

Babatha was the next witness of the paranormal, her incident far more frightening. Before the twins were born, John's grandmother, who was in poor health, "was scared she was going to die before she got to see the kids." Unfortunately, she did succumb before meeting her granddaughters. It was May 2000, when the girls were a month old. "We all went down for the funeral and we stayed in the same room, where we always slept," John said. "I didn't see it, but my wife swears this happened. She woke up in the middle of the night when the girls, who were sleeping in a big playpen, started crying. My grandmother was standing over them, and she said to my wife, 'Don't worry about them. I'll take care of them. Just go back to sleep.' But of course she got up anyway. It was unreal."

The house still stands. John's father bought it from his mother, but he sold it a year later to one of John's cousins, who "would always tell me that weird stuff like that would happen. She said she slept in that same room, and they had a greyhound dog. She said they would wake up at night and find the dog standing up, growling, its hair standing up like it was ready to eat something up, just staring at a corner of the room."

John enjoys teasing his girls by telling them, "We are gonna go down there and sleep in that room. But don't worry, the ghosts aren't gonna hurt you. They're all family.'" John points out that "nothing bad has ever happened. It's just strange. In that house, so many things have occurred and so many people have seen it. It's hard to believe, but it's true."

WILCOX COUNTY

A REALTOR'S DILEMMA

I bought this house and you know I'm boss.
Ain't no haint gonna run me off.
—Gene Simmons, "Haunted House," 1964

Historic houses are both a treasure and a burden to a community. Few old structures make it to the age of a century or more, and to remain habitable, they must be maintained and restored regularly. Few individuals either want or have the resources to preserve these buildings, and too many important structures sit empty for decades. Everyone wants to see these houses restored and everyone is sad when they are demolished, but what can be done? There are difficulties enough for historic homes, but imagine if the house is also thought to be haunted.

In the summer of 2008, a historic colonial house dating to 1850 went on the market in Abbeville but failed to sell at a seemingly cheap price. People started wondering, and questions were asked. Even more intriguing, one photograph in an online listing showed an upstairs landing, featuring an extensive area of…smoke?…ectoplasm? An Internet exchange erupted.

"5lilmonkeez," who "actually looked at this house," found it "a lovely house needing work," primarily heating and air conditioning, and upstairs, which was "just lathe & plaster." Concerning the paranormal: "Pretty sure it is haunted as well (just a feeling after stepping in the front door)."

"Nightwishfan," who stated that the house "appears to be in pretty decent shape," learned that the house had been up for auction, "with no high

In Georgia, every type of structure can be haunted, be it mansions, suburban houses or even mobile homes. *Earline Miles.*

bidders." On the photograph he could not fail to notice it: "There's also a slightly weird something on the right side of the upper landing." She called it "misty stuff" and found "a small 'x' with a circle around it inside of the 'mist,'" which might have been a bit of wallpaper. "It is somewhat rare for me to find anything (of a supernatural nature) in photos of homes for sale," although in a listing for a home in Ireland she once saw "a 'woman' peeking out the empty door of an old hunting cottage."

A woman named Dawn, with a double interest in realty and the paranormal (she founded and investigated for Four Seasons Paranormal), looked at the house with a client. She also found the inclusion of the misty photograph unusual, believing the realtors "have no clue what they posted." In addition to a possible haunting, she found the house to be secluded and close to railroad tracks and a cemetery, all things that have to be factored into the price of a house.

"Bulldawgfan" retorted that "in my 45 years of existence I have yet to see even the slightest suggestion of paranormal 'activity.'" It was her opinion that the railroad was little used and the cemetery out of sight.

"Atlantagreg30127" thought the house leaned a bit and that the interior was hopelessly outdated. He thought the ghost story a joke but stated that "the history can make a difference. If someone was killed or simply died inside the home, some buyers will shy away from it, driving the price down over time."

So, if your home is both for sale and haunted, who ya gonna call? Perhaps Dawn.

WORTH COUNTY

THE HAUNTED GHOST INVESTIGATORS

On October 9, 2009, five members of the Ghost Hunters of Scientific Theory (GHOST), an Albany-based outfit, descended on a rural home in Worth County to conduct an investigation. Ironically, the home was owned by two members of the organization.

The owners believed that the structure was built in about 1940; records are lacking because of a 1982 fire in the Worth County Courthouse in Sylvester that destroyed many documents. The property is historic, lying along a pioneer turnpike known as Thigpen Trail.

The couple purchased the house in 2006, but the two experienced no paranormal activity until they began renovations two years later. First, they saw a short shadow, probably that of a child, spring between the door into the kitchen and the dining room. Later, as they sat in the living room, a tall shadow walked in front of them. Both have heard the locked back door open and shut, and investigation always found the door securely bolted. Heavy, boot-like footsteps have been heard in a hall late at night, and knocking on the back door recurs often, with no one present. Phantom voices are heard; disturbingly, they most often speak the names of the homeowners.

One of their teenage sons and his friend were in his bedroom when a blanket draped across the door was drawn back halfway, as if someone in the hall were looking into the room. After several seconds, the blanket dropped back into place. Hearing a noise, the two turned to find that a pair of sunglasses had teleported from one dresser to another. As they looked, it still rocked from momentum.

The investigators heard shuffling in the house several times and a female voice singing indistinctly but "loud and clear" from outside the house. A week later, one of the homeowners heard a disembodied woman's voice singing inside the home. One investigator detected a voice whispering in her ear.

Among decipherable EVPs were, "Is that all you have?" apparently a response to an investigator's challenge to turn on a flashlight, and, to a further question about its identity, "I don't know who he is" and "And I knew who he is." Other EVPs seem to say, "I'm here, yeah," "I'm fine," "David," "Over here," "Hey, yeah," "You asked," "Help me," "You're wrong" and "Don't feel right."

Following a review of all the evidence, GHOST declared the house "haunted." "We seem to share our home…with a few harmless ghosts," Christi said. It occurred to her that "every house that I have lived in has had some level of paranormal activity (maybe they follow me)," she concluded. That is not an uncommon occurrence.

Christi grew up in an old house in Kentucky and heard "all kinds of things going bump in the night." She has had "countless personal experiences" with the paranormal in her forty years.

BIBLIOGRAPHY

Albea, Alice. "The Ghost on the Stairs." *Atlanta Journal*, November 19, 1933, Sunday Magazine section.

Americus Times-Recorder. August 3, 1955.

April W. "The Boy in Thornton House." Ghost Village, August 4, 2008.

Atlanta Constitution. "'Thing' Has Many Scared but Not Terrell's Sheriff." August 5, 1955.

———. "The 'Thing' Might Be Anything." August 4, 1955.

Barrett, W.F. "The Dale Tower, Georgia, U.S.A., Case." *Proceedings of the Society for Psychical Research*, no. 25, part 64 (August 1911).

Bi-City Paranormal. "Abandoned Farm House between Preston and Plains Georgia."

Big Bend Ghost Trackers. "Case # 100607 Crime and Punishment Museum." 2007.

———. "Rylander Theater." January 6, 2007.

Bigfoot Field Researchers Organization. "BFRO Report 2279: Multiple Witness Sighting near Beards Creek Church." July 25, 1999.

Boland, Mary B., ed. *Sparks from the Flint*. Cordele, GA: Independent Study Program, Crisp County High School, 1976.

Brunswick News. "Legends." October 30, 1979.

Burrison, John A. *Storytellers: Folktales & Legends from the South*. Athens: University of Georgia Press, 1989.

Carly, Farrell. "Witnesses Say Historic Theater Is Haunted." *Americus Times-Recorder*, October 7, 2005.

Castle of Spirits. "Cumberland Island." April 1, 2002

———. "Cumberland Island—The Sequel." July 2008.

City-Data Forum. "Abbeville 1850s Colonial House, Why So Cheap?"

Cobb, Albert L. *Danny's Bed: A Tale of Ghosts and Poltergeists in Savannah, Georgia.* Savannah, GA: Whitaker Street Press, 2000.

Collins, Genie. "Ghosts in the Rylander?" *Americus Times-Recorder*, January 5, 2007.

Cone, Jana. "A South Georgia Haunting." *Tifton Gazette*, October 31, 1985.

Cox, Kimberley. "G-G-Ghost St-t-tory. *Savannah Morning News*, January 16, 1972.

Crews, Harry. *A Childhood: The Biography of a Place.* New York: Harper & Row, 1978.

Crossing the Line Paranormal. "Private Residence: Fitzgerald, GA."

Davis, Isabel, and Ted Bloecher. *Close Encounters at Kelly and Others of 1955.* Evanston, IL: Center for UFO Studies, 1978.

Davis, Jingle. "That's the Spirit: Ghostbusters Make House Call at Valdosta Inn." *Atlanta Journal Constitution*, March 2, 1997.

Dawson. "Haunted Places in Georgia." Shadowlands. http://www.theshadowlands.net/places/georgia.htm.

Doster, Allie. "Reminiscences Dead River Section." *Montgomery Monitor*, May 21, 1931.

Dougherty County Paranormal Investigators. "Crime and Punishment Museum 09-01." 2009.

———. "Martha's Flowers 09-06." 2009.

Dunlop, Joe. "'Ghostbuster' Called to Investigate Bell House." *Valdosta Daily Times*, February 2, 1992.

———. "No Ghosts Found in Bell House." *Valdosta Daily Times*, March 2, 1997.

Ebb Tide. "Mary De Wanda & the Tallman." 1978.

Farrant, Don. *Ghosts of the Georgia Coast.* Sarasota, FL: Pineapple Press, 2002.

Farrell, Carly. "Witnesses Say Historic Theater Is Haunted." *Americus Times-Recorder*, October 7, 2007.

Fate. "Dream that Solved a Murder" (October 1, 1955).

Fleming, Billy. "Mumbles." *Early County News*, August 4, 2010.

Floyd, E. Randall. "Family Slowly Came to Accept Apparitions." *Augusta Chronicle*, February 6, 2000.

———. "The Ghost that Came to Stay." *More Great Southern Mysteries*. Little Rock, AR: August House, 1990.

Fussell, Fred C. "Telling the Future." E-mail message to author, June 18, 2014.

GHOST. "Private Residence, Worth County, Ga." October 9, 2009.

Ghosts of America. "Adel, Georgia Ghost Sightings."

———. "Pearson, Georgia—Ghost Sighting."

Ghosts of Georgia Paranormal Investigations. "Private Residence, Folkston Ga." July 16, 2011.

Goodwin, Carla. "Letters to the Editor." *Coastal Courier*, October 31, 2007.

Gray, Daniel. "Irwin County Ghost." Interview by author, June 9, 2009.

Griffin, Mike. "The 'Hairy' Man." Listen Boys—I Hear the Hounds, January 13, 2013.

Hardy, Wayne. "Has One Family Learned to Live with Ghosts in Their Midst? The Unexplained Is Just Part of Everyday Life for the Kodobocz Family." *Blackshear Times*, October 24, 1987.

Historic Ghost Watch and Investigation. "Pearle's Home." 2005.

———. "South Georgia Home—Pearle's House." 2006.

Hurst, Robert Latimer. *This Magic Wilderness, Historical Features of the Wiregrass*. Waycross, GA: Wilderness Publications, 1982.

"Juice." "Waynesville Georgia Ghost Sightings." Ghosts of America.

"Kim L." "The Ghost in Room 102—Days Inn, Metter." Days Inn, November 19, 2012.

Kramer, Joyce. "White's Bridge Legends." *Post-Searchlight*, February 28, 2011.

Lane, Jana. *Tifton Gazette*, October 31, 1995.

Love, Margie. "Haunted House on Liberty." *Coastal Courier*, October 29, 2007.

———. "Violent Death of Salesman Haunted Main Street Home." *Coastal Courier*, September 10, 2012.

McDaniel, Jessica. "Hard-Up Road/Seven Churches Road." Southwest Georgia in Photographs, June 2, 2014.

Miles, Jim. *Weird Georgia: Close Encounters, Strange Creatures, and Unexplained Phenomena*. Nashville, TN: Cumberland House, 2000.

Morris, Rachel. "Cold Room Tapping." Ghostvillage, May 1, 2001.

"Mph." "Claxton, Georgia Ghost Sightings." Ghosts of America.

Mullis, Rachel. "Encounters at My Grandparent's House." Ghostvillage, September 19, 2005.

O'Quinn, Carolyn. "The Golden Isles Has Its Own Ghosts, Goblins." *Brunswick News*, October 30, 1987.

Pope, Jessica. "Voices from beyond the Grave Recorded at Vito's Pizzeria and Lounge." *Valdosta Scene* (October 31, 2007).

Roadside America. "Fort Gaines, GA—Gravity Hill."

Roberts, Nancy. *Georgia Ghosts*. Winston-Salem, NC: John F. Blair, Publisher, 1997.

Ross, Michael. "Ghost Trackers Say Custodian Haunts Rylander Theatre." *Americus Times-Recorder*, January 8, 2007.

Russell, Randy. *Ghost Cats of the South*. Winston-Salem, NC: John F. Blair, Publisher, 2008.

The Rylander Theatre. "Rylander Theatre History."

Savannah Morning News. "Albany Comes Forward with Ghost in Old Jail Building." June 9, 1922.

———. "A Ghost Story." October 23, 1885.

———. "A Haunted House." April 27, 1893.

———. May 13, 1891.

———. "The Quarrel." October 5, 1886.

———. "The Rain Fall." October 10, 1886.

———. "A Ride Among Ghosts." January 1, 1893.

———. September 15, 1890.

———. "Strange Adventure." March 7, 1891.

Schlosser, S.E., and Paul Hoffman. *Spooky Georgia: Tales of Hauntings, Strange Happenings, and Other Local Lore*. Guilford, CT: Globe Pequot Press, 2012.

Smith, Gordon Burns, and Anna Habersham Wright Smith. *Ghost Dances and Shadow Pantomimes: Eyewitness Accounts of the Supernatural from Old Georgia*. Milledgeville, GA: Boyd Pub., 2004.

Southeastern Ghosts and Hauntings. "Spirits of the Sinyard House—Hawkinsville, Georgia." October 22, 2012.

Southern Ghost Hunters of Tifton. "Case # 0104 Vito's Pizza Valdosta Georgia."

———. "Case # 0111 Residential—Waycross, Ga."

———. "Case # 035 Jones St., Georgia."

South Georgia Paranormal Investigators. "Fitzgerald, Georgia." 2009.

Spook Hunters. "June 2004—Antebellum Plantation—Stone Mountain, Georgia." June 1, 2004.

St. John, Wylly. "Ha'nts at the Hawthorn House." *Atlanta Journal*, October 26, 1947, Sunday Magazine section.

StrangeUSA. "Cemetery on Burnt Church Rd."

Sumner, JD. "Tifton Has Its Share of Ghost Stories." *Tifton Gazette*, December 7, 2005.

Thompson, Chuck. "Former Jail Turned Museum Hoping to Scare Up Tourism." *Macon Telegraph*, February 9, 2009.

Topix. Discussion on Pearson Lights, April 2010, March 2011. http://www.topix.com/forum/city/douglas-ga/TCE9VQB8OLU5Q62Q2.

TripAdvisor. "Beautiful but Haunted…Barber-Tucker House Bed and Breakfast." June 1, 2008.

Trout, Dan. "What Happened to Green Square Ghost?" *Thomasville Courier*, October 7, 1976.

Wagner, Stephen. "Little Child's Ghost." Your True Tales, March 2013.

Wells, Jeffery. "Montgomery County's Cooper-Conner House and Ghost Ram." Georgia Mysteries, November 13, 2008.

ABOUT THE AUTHOR

Jim Miles is author of seven books of the Civil War Explorer Series (*Fields of Glory*, *To the Sea*, *Piercing the Heartland*, *Paths to Victory*, *A River Unvexed*, *Forged in Fire* and *The Storm Tide*), *Civil War Sites in Georgia* and two books titled *Weird Georgia*. Five books were featured by the History Book Club, and he has been historical adviser to several History Channel shows. He has also written seven books about Georgia ghosts: *Civil War Ghosts of North Georgia*, *Civil War Ghosts of Atlanta*, *Civil War Ghosts of Central Georgia and Savannah*, *Haunted North Georgia*, *Haunted Central Georgia*, *Haunted South Georgia* and *Mysteries of Georgia's Military Bases: Ghosts, UFOs, and Bigfoot*. He has a bachelor's degree in history and a Master of Education degree from Georgia Southwestern State University in Americus. He taught high school American history for thirty-one years. Over a span of forty years, Jim has logged tens of thousands of miles exploring every nook and cranny in Georgia, as well as Civil War sites throughout the country. He lives in Warner Robins, Georgia, with his wife, Earline.